IMAGES
of America

RANCHO CUCAMONGA

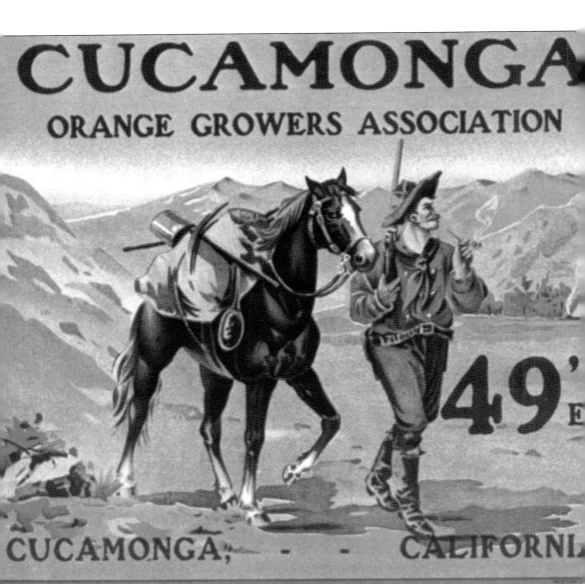

ORANGE CRATE LABEL FOR 49'ER BRAND. People from far and wide traveled to Cucamonga. Some merely stopped for water at one of the many creeks flowing from the mountains. Some came to start farms or vineyards, and others came to mine in the local mountains. Still, others built stores and businesses. (Author's collection.)

ON THE COVER: Visitors gather in the shade of the Thomas Winery in June 1954 for one of the many old car shows held there. (Photograph by Walt Westman.)

IMAGES
of America

RANCHO
CUCAMONGA

Paula Emick

ARCADIA
PUBLISHING

Published by Arcadia Publishing
Charleston, South Carolina

Printed in the United States of America

Library of Congress Control Number: 2010941648

For all general information, please contact Arcadia Publishing:
Telephone 843-853-2070
Fax 843-853-0044
E-mail sales@arcadiapublishing.com
For customer service and orders:
Toll-Free 1-888-313-2665

Visit us on the Internet at www.arcadiapublishing.com

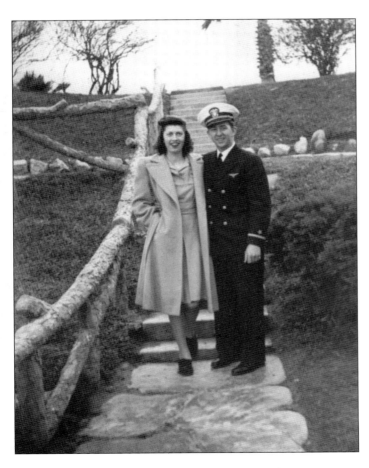

AMERICAN AUDIENCE, WORLD WAR II. Bill and Polly Thomas, like many Americans, first heard of Cucamonga on the radio show the *Jack Benny Program* in the 1940s and on his television show in the 1950s. Audiences laughed at the silly-sounding name announced in train station skits, never thinking it would become one of the top places to live in the 21st century. (Author's collection.)

CONTENTS

ACKNOWLEDGMENTS

Collecting the history of Rancho Cucamonga has been a fascinating journey made possible by the help of many individuals. I owe a great deal of thanks to the following people.

First, I must thank Nancy Sanders, Kay Presto, Debby Balders, Barbara Drake, and Sue Sharra for encouraging me and pointing me in the right direction. I thank Esther Billings, Claude Ellena, Jim Frost, Luana Hernandez, Shirley O'Morrow, Paul and Winnie Sage, and Lucille Thompson. They generously gave me their time and shared their family stories and photographs.

Special thanks are given to Ed Dietl of the Historical Preservation Association of Rancho Cucamonga, Marilyn Anderson of the Cooper Regional History Museum, Kelly Zackmann of the Robert E. Ellingwood Model Colony History Room, William Araiza of the Chaffey Community College Library, and Pam Strunk of the John Rains House for patiently answering my many questions and helping supply photographs.

A great deal of thanks also goes to Mayuko Nakajima, the City of Rancho Cucamonga's assistant planner, and Kayre Wood from the Rancho Cucamonga City Library, as well as their staffs, who have been creating the city's archives and oral history project. I also thank the many individuals who donated photographs to those projects.

Great appreciation also goes to winery owner Gino Filippi and the Gabrielino/Tongva Indian councils for preserving history for future generations.

Ike of Metro Photos and Ben Morrow and staff of Pip Printing are greatly appreciated for keeping me in prints and copies.

I cannot thank my husband and family enough for their help, patience, and computer tech support; and I thank my parents, who taught me an appreciation for history.

Thank you to my best friend, Dawn Collins—I am indebted to you for your last-minute photography work.

Lastly, I applaud the immeasurable patience of acquisitions editor Debbie Seracini, who kept this project on track.

Some photograph acknowledgments may have been shortened to save space. All images used in this book are courtesy of the City of Rancho Cucamonga's archives unless otherwise noted.

INTRODUCTION

"Cuca-what?" is often what I hear when telling those outside of California where I live. It's then followed by a chuckle and the question, "Is that a real place?".

Yes, Cucamonga is a real place with a real history.

I have to admit that, when I was growing up in another small town in the Los Angeles area, I was one of those who laughed at the name. To my young ears, "Cucamonga" sounded like a far-off place beyond the horizon and next door to the Land of Oz. It was an attitude I picked up from my parents, who were among the millions of people who listened to and laughed at the *Jack Benny Program* in the 1940s. Dad would recite Mel Blanc's famous line of the train station announcer who called out the departure for "Anaheim, Azusa, and Cuc . . . a . . . mongaaa." For my folks, "Cucamonga" was slang for "way out in the middle of nowhere."

Decades later, my husband and I moved way out there to the newly incorporated Rancho Cucamonga. I was amazed to see how much "there" there was in Cucamonga. The golden age of agriculture had passed, leaving just a few private orange groves and vineyards and the occasional flock of sheep being watched by a Basque shepherd. An abundance of history remained to become the foundation of the new city's big plans for its future. Large signs in the old vineyards proclaimed "Coming Soon" for well-planned shopping centers and housing developments. It was to be a planned community, with all architecture reflective of its rich past. But where did that silly name come from?

The word *cucamonga*, meaning "a place of many waters" or "a sandy place," comes from the native Tongva language. Both meanings are correct. The many natural springs and intermittent creeks were a superb water source for the Tongva. The creeks that trickle from the mountains in the scorching summers become rushing rivers in times of heavy rain. Torrential floodwaters spread huge swaths of rocks and sandy soil across the valley, creating an alluvial fan. The Indians, who called themselves the Tongva, named their village, land, and themselves "Cucamonga."

The first written record of the word "Cucamonga" comes from the journal entry of Fr. Francisco Garces. Father Garces, who was part missionary and part explorer, was traveling with famous Spanish trailblazer Juan Bauteista de Anza, after whom the Anza-Borrego State Park is named. Anza was leading a group of 241 Spanish colonists from Sonora, Mexico, to Alta, California, to establish what would one day be San Francisco. Garces left Anza's group near the Colorado River to explore up ahead on his own. He traveled west on the Mojave Trail through the desert and then crossed the mountains and joined the Santa Fe Trail, a path that later would become part of Route 66.

On March 23, 1776, Garces recorded in his journal that he met some Indians who invited him to come eat at their village. These Indians introduced themselves as Cucamonga and brought him west along the San Gabriel Mountains to their settlement. Thus began Cucamonga's history of being a rest stop for travelers, as well as a destination for those wishing to start a new life.

California, once Spanish land, became part of Mexico in 1821. Mission lands were broken up and sold as homesteads. In 1839, Tiburcio Tapia, a Mexican army officer and grandson of one of the colonists who traveled with Captain Anza, received a land grant from Governor Alvarado of California. His Cucamonga Rancho covered 13,000 acres south of the San Gabriel Mountains and east of the San Antonio Creek, or what is now known as the towns of Upland, Ontario, and Rancho Cucamonga.

Tapia built a fortresslike adobe on top of Red Hill, allowing for a magnificent view of the valley. He raised cattle and sheep and planted a small vineyard where the Thomas Winery is today. Tapia's home and winery no longer exist but a legend about him does. Story has it that Tapia was also a wealthy smuggler. He went out late one night and buried his fortune. However, he died suddenly in 1845 before revealing where it was hidden. Though stories abound, no treasure has ever been found.

California joined the United States in 1850. Tapia's heirs sold the Cucamonga Rancho to an American Southerner named John Rains and his wife, Maria Merced Williams, of the Chino Rancho in 1858. Rains expanded the vineyards and invested in several business ventures. He was mysteriously murdered as he rode horseback through what is now San Dimas. The Cucamonga Rancho was foreclosed upon in 1871.

The northwestern portion of the old rancho eventually became Alta Loma, and the southern part kept the name Cucamonga. Brothers George and William Chaffey from Ontario, Canada, purchased the land on the eastern side and named their colony Etiwanda. The Chaffey brothers also purchased rancho land that would one day become the towns of Upland and Ontario. The innovative Chaffeys brought water and utilities to the town and built Chaffey High School and College in Ontario.

From the late 1800s to the mid-1900s, Cucamonga attracted a variety of nationalities. Word had spread around the world about the valley with perfect soil and weather to produce excellent grape harvests. Italian immigrants flocked to southern Cucamonga and Etiwanda to set up their vineyards and wineries. Chinese laborers who had worked for the railroads came to the citrus groves and vineyards, as did the Mexicans. Germans, Russians, and Canadians came to start ranches and businesses. After World War II, a Lebanese craftsman named Sam Maloof set up shop in Alta Loma, changing the art world.

The three small communities called Alta Loma, Etiwanda, and Cucamonga prospered. Stores were built, farms plowed, and groves and vineyards planted. Freight trains delivered Cucamonga peaches and citrus to states in the East. The Red Car trains and buses connected people to jobs, stores, and schools miles away.

Prohibition, the Great Depression, and freezes drastically damaged the winery and citrus business. Unable to recover and pay the skyrocketing property tax, agriculture decreased, and ranchers sold their land. Light industry and suburbia took over the old vineyards and packinghouses.

A change was needed to direct the suburban growth and build a city that would benefit all three communities. The towns of Alta Loma, Etiwanda, and Cucamonga incorporated in November 1987 to create the city of Rancho Cucamonga.

By 1996, Rancho Cucamonga was named one of the top places to live in America by *Money* magazine. The land of many waters once again became the place to be.

This book is meant to be a brief overview of Rancho Cucamonga's past. Any oversight of people or events is unintentional. I encourage all to write their stories of this amazing place and their families.

One

FROM KUCAMONGA TO
CUCAMONGA RANCHO

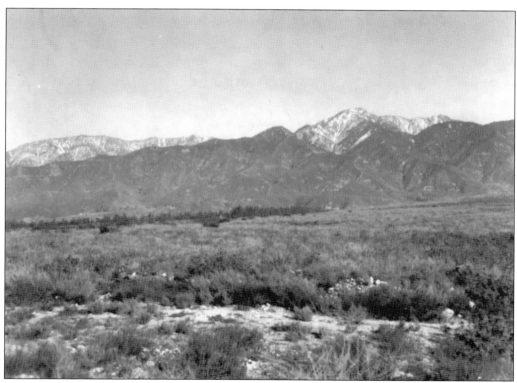

THE KUCAMONGA HUNTING GROUNDS. The foothills provided deer, antelope, rabbit, quail, and coyote for food and clothing. The chaparral plants provided herbs, food, medicines, and basket-making materials. Acorns from oak trees (not seen here) were the basis of the Tongva diet. This particular piece of land became the site of Chaffey College in 1960. The "Kucamonga" spelling is sometimes used to denote the early Cucamonga Tongva times. Other old-time spellings include Cocomonga and Kucomonga. (Chaffey College.)

SYCAMORE GROVE AT THE BASE OF RED HILL. A dirt path called the Santa Fe Trail, now Foothill Boulevard, brought Spanish explorer Captain Anza to a shady Sycamore grove by trickling creeks. The Spaniards named the area Arroyo Los Osos, or "Bear Gulch," because of the many peaceful bears they saw there. The names of two local schools were derived from those bears. (Dawn Collins.)

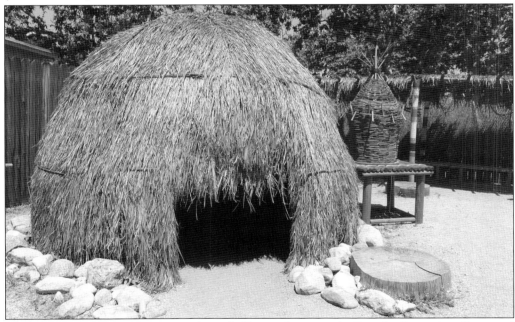

REPLICA TONGVA SITE. Here is a replica of a Tongva house at the Rancho Santa Ana Botanical Gardens in Claremont. The Tongva's home was called a _kich_ (pronounced "keeh"). Reeds were woven onto a dome structure. The doorway, which was intentionally built low, had to be entered backwards to show those inside that the visitor was not an enemy. An immense kich was built to hold the whole village for tribal meetings and ceremonies. (Author's collection.)

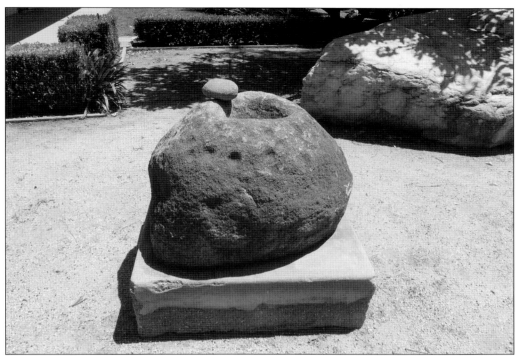

METATE (GRINDING STONE). Stones and boulders of all sizes were used as kitchen equipment by the Tongva natives. The shallow hole on top of the metate was filled with acorns or herbs that the women crushed with handheld grinding stones. Acorn mash was a staple of the Tongva diet. This metate is on display at Etiwanda Intermediate School. (Dawn Collins.)

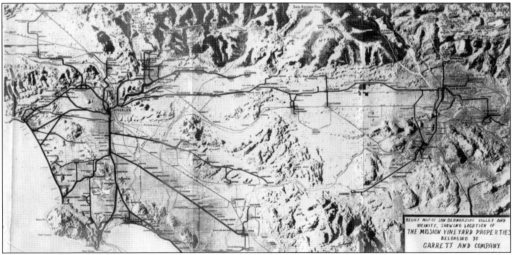

SOUTHERN CALIFORNIA MAP, C. 1920S. This map coincides with the area controlled by the San Gabriel Mission from the 1700s to the mid-1800s. Missionaries collected the local Indians, who were called *Gabrielinos* by the Spanish priests, from this area and took them to the mission to live. The Kucamonga tribe did not reestablish themselves after the mission era. Coincidently, this map was used for property appraisal of Garrett's Mission Vineyard and Winery. (Model Colony Room.)

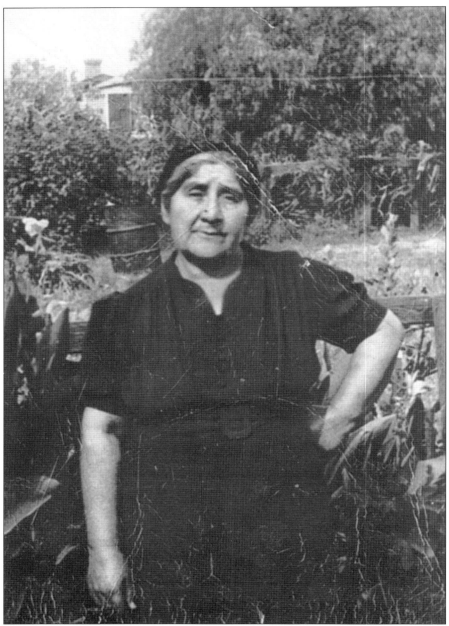

TONGVA WOMAN. Pastora Rosa Valenzuela was born in 1887 in San Gabriel. Her parents and grandparents were some of the Gabrielino Indians at the San Gabriel Mission. When the missions secularized, many of the Tongva went to work at the nearby ranchos. The Tongva nation was made up of hundreds of small family tribes, each with their own chief. There was no large organized society for the mission Indians to return to decades after their villages had been evacuated. Tongva villages, such as Kucamonga, did not reestablish themselves but blended in with other tribes and the Mexicans and Spanish colonists. Because of this, there are many present-day Tongva living in Southern California. Valenzuela is connected to Cucamonga in two ways: she was a cousin of Doña Merced and some of her descendents still live in Rancho Cucamonga. (Barbara Drake.)

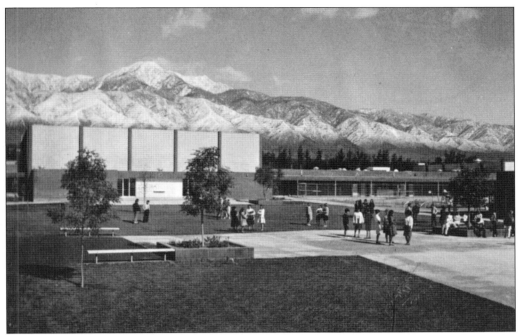

ALTA LOMA HIGH SCHOOL, 1963. Remains of the Kucamonga village were found during the building of Alta Loma High School on Baseline Road. Metates, grinding tools, and arrowheads were some of the artifacts recovered. (Alta Loma High School.)

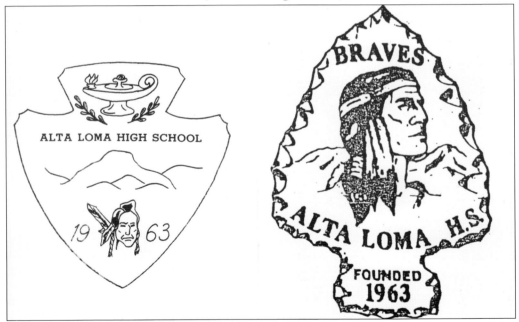

ALTA LOMA HIGH SCHOOL LOGO. The high school chose to honor the rich history of the Kucamonga village site by having a proud Tongva brave as the school's symbol and mascot. On the left was the original 1963 arrowhead symbol, and on the right is the present-day logo. (Alta Loma High School.)

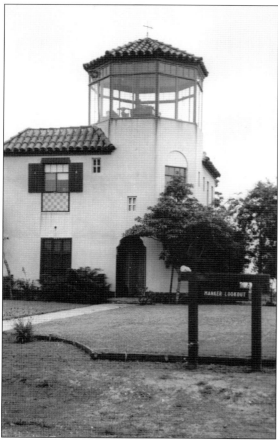

THE OLD HOMESTEAD, 1964. The last remaining building of Tapia's Cucamonga Rancho was a barn-type building that stood on the east side of the Thomas Winery on Foothill Boulevard. Tapia planted cuttings from the San Gabriel Mission's vines that were originally brought from Italy. The Thomas Winery is the oldest in California. The Old Homestead was completely destroyed in the 1969 flood.

RED HILL FORESTRY LOOKOUT TOWER, c. 1940s. Now a private residence, the lookout was built to take advantage of the same magnificent view of the valley that Tapia had from his rancho home. During World War II, the forestry service looked for enemy aircraft in addition to forest fires. The exact location of Tapia's adobe is not known. Today, that view is blocked by trees, buildings, and air pollution. (Cooper Museum.)

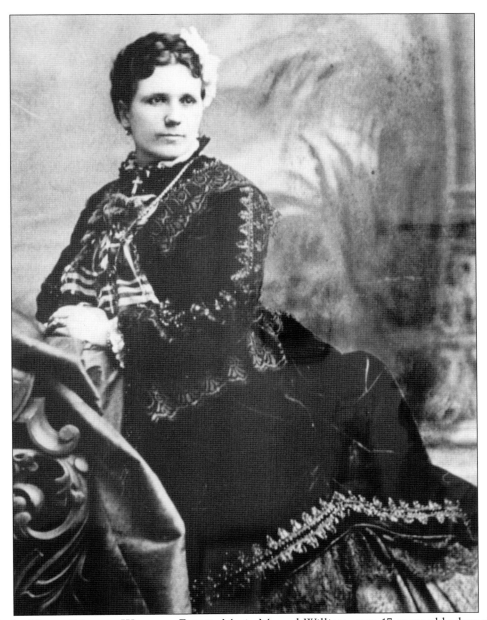

Doña Maria Merced Williams Rains. Maria Merced Williams was 17 years old when she married John Rains just days after her father's funeral in December 1856. Rains used his new wife's inheritance to purchase the Cucamonga Rancho from Tapia's heirs and invest in the Bella Union Hotel in Los Angeles. Rains expanded Tapia's original vineyard in addition to raising cattle. His renowned grapes fetched high prices in the Los Angeles market. In November 1862, he was fatally shot while riding to Los Angeles. His murder was never solved. His death left Doña Merced widowed with four small children and pregnant with their fifth. Some people suspected her as an accomplice. A severe drought decimated the grape harvests and their cattle herds. The Cucamonga Rancho went into foreclosure in 1871. Doña Merced moved her family to Los Angeles. (Model Colony Room.)

RAINS HOUSE, C. 1960S. By 1971, the building was vacant and severely vandalized. A local teacher named Maxine Strane often took her classes to see the historic home. On one such trip, they found a team of bulldozers about to tear down the house. She and the schoolchildren convinced the owner not to destroy the building. Strane campaigned fervently for the preservation of the city's original building. At last, the county took over the property. The Las Guis volunteers have beautifully restored it. (Model Colony Room.)

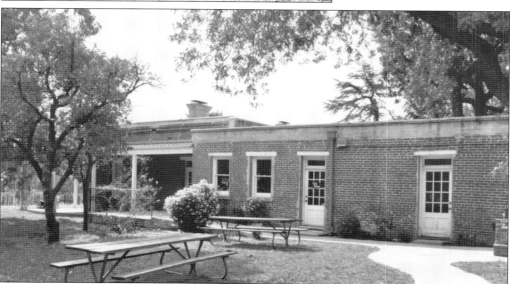

THE RAINS' HOUSE. Built in 1860, this was the first fired-brick building in San Bernardino County. The brickworks were located directly south of Red Hill, where the natural red clay was easily available. Each room has a fireplace for heating. A stream of water ran through the kitchen and center courtyard. Its flat roof was sealed with tar, or "brea," brought from the Orange County area. (Kelly Zackmann.)

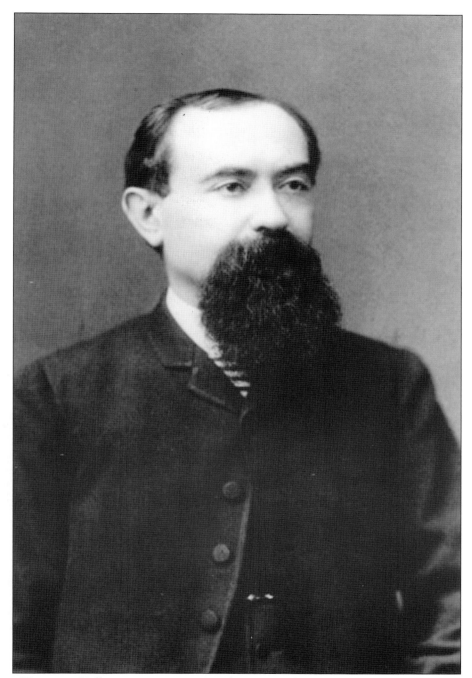

ISAIAS HELLMAN. Hellman came to Los Angeles in 1859 from Germany. He became a leading financier and banker who bought and sold large parcels of land. He was a key investor in the Southern Pacific Railroad and Los Angeles's utility companies and commercial developments. Hellman is also credited for helping to fund the University of Southern California (USC) and serving as a USC regent. He purchased and resold many of Southern California's foreclosed ranchos, including the Cucamonga. (Author's collection.)

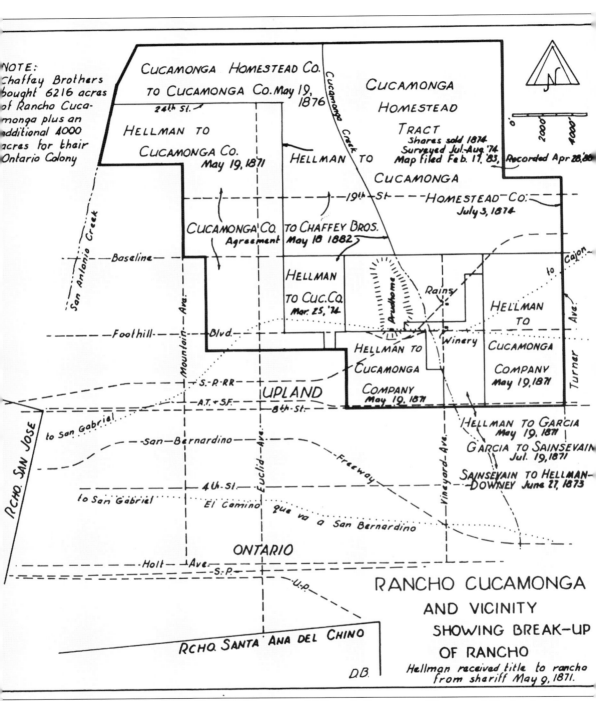

MAP OF CUCAMONGA RANCHO'S LAND DIVISION. Hellman's Cucamonga Homestead Co. land and the Hermosa Colony (not shown) would one day become Alta Loma. The Cucamonga Company parcels stretched over parts of Alta Loma, Cucamonga, and Etiwanda. (Model Colony Room.)

Two

ALTA LOMA

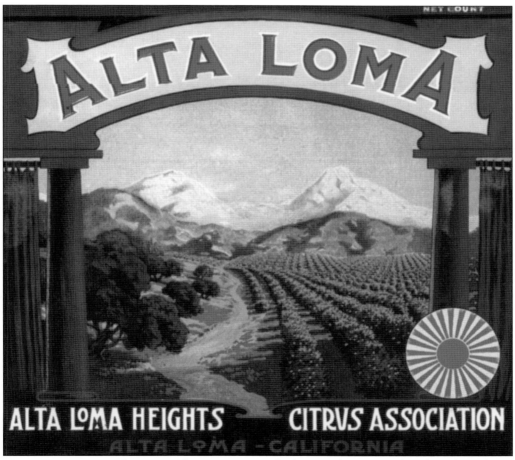

NAMING THE TOWN. The name Alta Loma means "high ground" in Spanish. When the railroad brought a line to the citrus groves on the foothills, a contest was held for residents to name the new station. Alta Loma was the winning entry, and the town's name was established. (Author's collection.)

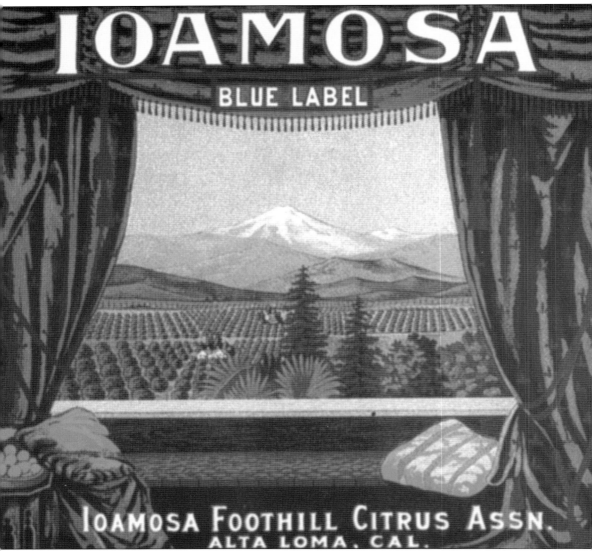

IOAMOSA ORANGE CRATE LABEL. Alta Loma's first name was Hermosa, meaning "beautiful" in Spanish. In 1881, two men from Pasadena, German-born Adolf Petsch and Judge Benjamin Eaton, were riding by on a buggy and noticed 160 acres of land with its own water source that was owned by Henry Reed. A deal was made for the land and the water rights to Deer Canyon. Judge Eaton suggested naming the beautiful place Hermosa. A nearby land parcel was called Iowa Tract. The town's second name was created in October 1887 when the two colonies were combined to create the single community of Ioamosa. (Author's collection.)

THE HERMOSA SCHOOL, 1921. Alta Loma's first school, on the corner of Nineteenth Street and Amethyst Avenue, was a wooden building serving the children of the Iowa and Hermosa colonies. In 1921, this concrete school was built in its place. It had two classrooms and a library. Each student was given a piece of ground in front of the school to grow a garden as part of the school's curriculum. (Dawn Collins.)

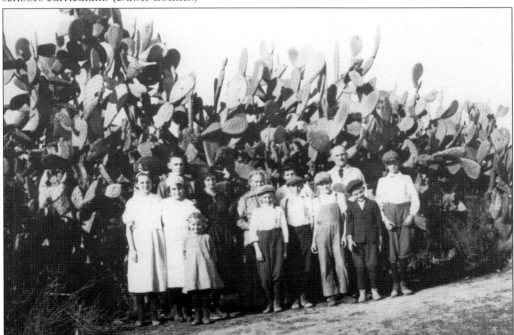

ALTA LOMA SCHOOLCHILDREN, C. 1930S. Possibly on their way to school, these children stand in front of a natural fence of prickly pear cacti. Ranchers would sometimes plant a row of cacti to serve as a fence and keep cattle inside and rustlers outside the property. The paddle-shaped leaves and red fruit are edible.

THE DEMENS/TOLSTOY HOUSE. Known as the Stone Castle, Demens bought this 27-room house from a Chaffey family member whose new wife did not want to live in Ioamosa. It was originally used as a family vacation home. Once an imperial guard for the czar in Russia, Demens emigrated to find a better life with relatives in Florida. There, he ran a lumber mill and constructed the railway to St. Petersburg, which he named after his childhood hometown. In 1880, Demens moved his family to Los Angeles and bought a citrus ranch in Ioamosa. He convinced railroad baron Henry Huntington to run the railway northeast to Ioamosa. A contest was held to name the new depot. The name to Alta Loma was the winning entry and also became the town's permanent name. Demens's daughter Vera married Andrew Tolstoy, nephew of the famous Russian author of *War and Peace*. Captain Demens's newsletters persuaded many Russians to come to California. Family members continue to live there. (Dawn Collins.)

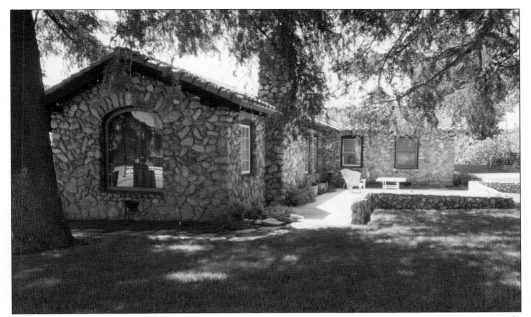

CHERBAK HOUSE. Got rock? Build a house. This is one of several stone houses the Cherbak family built by hand. Clean, smooth, round stones preferred for building were gathered from the canyons by the streams. Their six sons and a team of mules cleared wagonloads of rocks and boulders jokingly called "Cucamonga potatoes" before planting their fruit trees. Once settled, their father went back to working as a publisher, as he had been in Russia. (Dawn Collins.)

THE CHERBAK FAMILY HOME. The Russian family, the Cherbaks, took Demens's advice to immigrate to the Ioamosa Colony in 1898. They built this beautiful 16-room house for their large family. A.P. Cherbak returned alone to Russia in 1905 to help with the new government replacing the czar. The new regime did not allow him to return to America, and he died there. (Dawn Collins.)

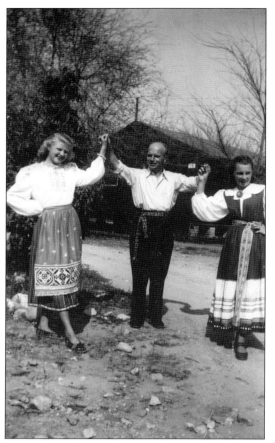

IMMIGRANTS, C. 1950. Captain Demens wrote Russian newsletters, influencing hundreds of Russians to immigrate to Cucamonga with promises of work in the citrus industry. Eastern European emigrants came in waves throughout the first half of the 20th century. These Estonian dancers in traditional folk dress are just a few of the many who came to California for a better life. (Cooper Museum.)

A CALIFORNIA PACKINGHOUSE. Like other citrus towns, Alta Loma had several packinghouses, such as this one. Characteristic of the Industrial Age, quick-paced assembly lines were arranged along conveyor belts. Fruit was loaded from trucks onto conveyor belts, which transported it around the building to be sorted and packed. (Model Colony Room.)

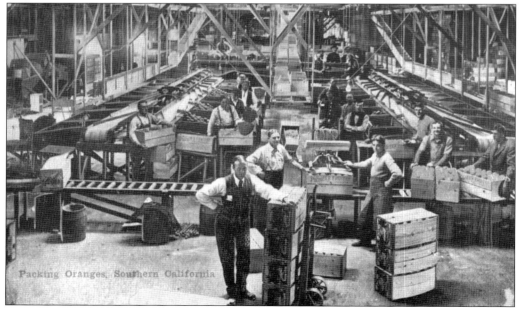

Packing Oranges, Southern California

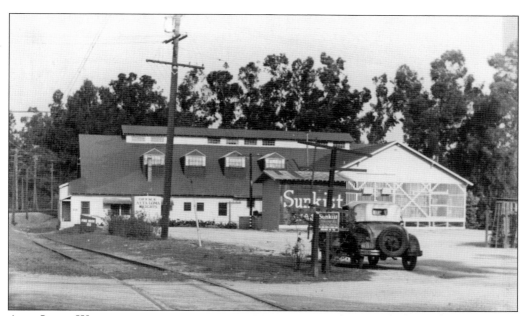

ALTA LOMA WAREHOUSE COMPANY. This packinghouse on Amethyst Avenue was built next to train tracks for easy loading. Growers' associations shared the packinghouses. When a new packinghouse was built on the other side of the tracks, this facility became a storage house for oranges. (Ed Dietl.)

PACKING ORANGES. Sunkist had numerous packinghouses in the Cucamonga region. They bought oranges, lemons, limes, and grapefruits from local growers' exchanges. In the beginning, packers would wrap each individual fruit in a piece of tissue paper stamped with the Sunkist name. The time-saving machine that would stamp the name onto the fruit came later. (Model Colony Room.)

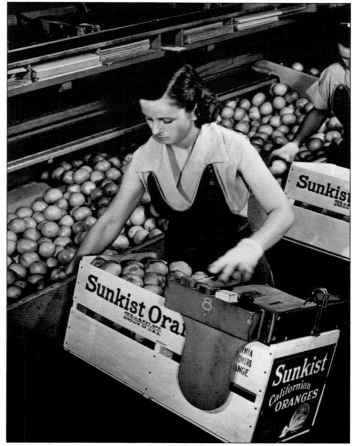

THE ALTA LOMA TRAIN STATION. The train station changed the lives of the town's residents. Trains enabled Demens and other the orchard owners to ship their fruit to Los Angeles and out of state. Local students could take the train to Chaffey High School and College in Ontario. Residents could commute to jobs and shop in other towns.

AMETHYST AVENUE, 1918. Unusually, low snowfall covers the fruit groves at the very top of Amethyst Avenue north of Banyan Street. Freezing temperatures are dangerous for citrus fruits. At night, farmers would listen for frost warnings on the radio. Frost meant that they would spend the night in the groves to keep the oil-burning smudge pots lit. The smoke kept the air just warm enough to prevent the citrus from freezing. As seen here, both citrus and deciduous fruit trees were planted along the mountains.

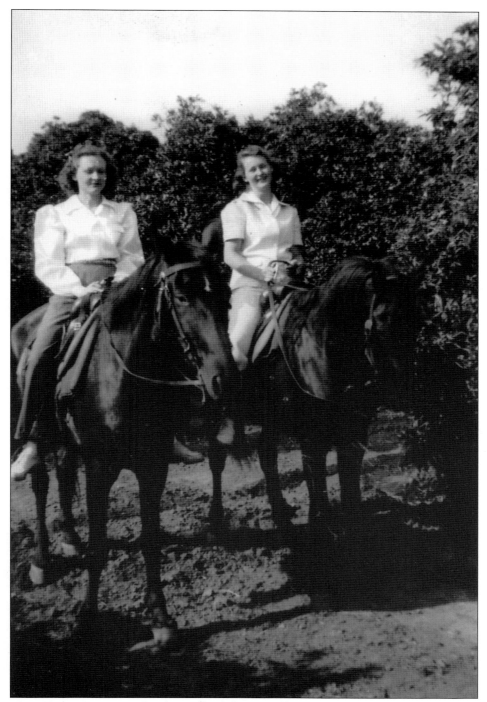

THE GILL TWINS. Miriam and Esther Gill ride borrowed horses through the orange groves. North Alta Loma has long been home to horse ranches and still has white-railed bridle paths today. In the early days, horses were needed for pulling farm wagons and plows. Some ranches specialized in breeding a particular type of horse, such as Arabian or racing thoroughbreds. (Esther Billings.)

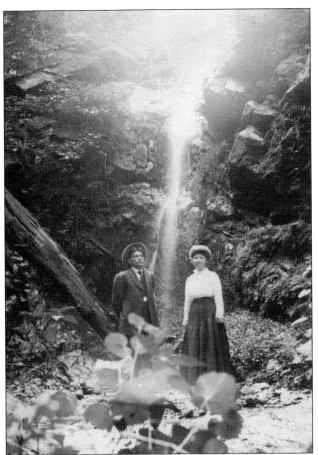

POSTCARD, C. 1900. A couple enjoys the refreshing coolness of a local waterfall. The water from Cucamonga, Deer, and Day Creeks enabled farms and towns to grow and flourish. Before the washes were built to control flooding, creeks flowed freely across the foothills. Eventually, George Chaffey introduced a specialized method of water delivery that allowed people to farm in the Cucamonga region. (Cooper Museum.)

RABBIT HUNT. Rabbits were plentiful. The tender shoots and leaves of farmers' gardens and young trees were irresistible to the jackrabbits and cottontails. So many rabbits inhabited the area that farmers would have rabbit hunts in an attempt to control the population. Here, the Araiza family and neighbors show off the day's bounty. Sitting on the far left is William Louis Araiza, third from the left is Louis G. Araiza, and fourth is William E. Araiza. The others are unidentified. (William Araiza.)

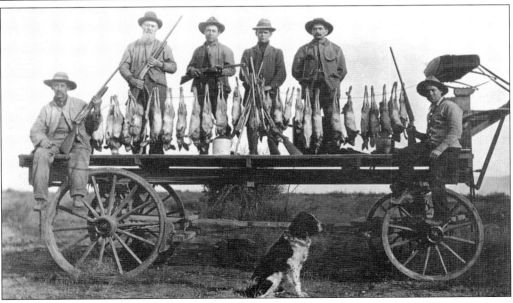

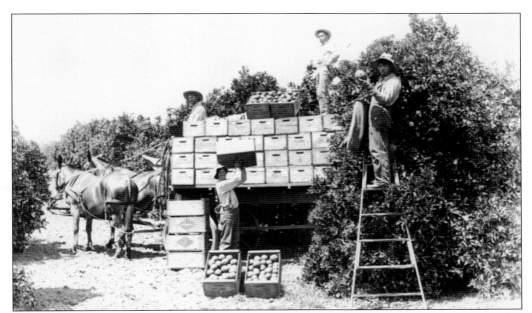

HARVESTING ORANGES. Citrus groves covered the foothill regions from Redlands to Los Angeles. Some of the laborers were local residents who moved from ranch to ranch with the seasons and harvests. Others came from different regions, including Mexico, just for harvest times. Pictured are Asian and Hispanic workers posing for one of the many citrus associations that served the Cucamonga and Upland area ranches. (Model Colony Room.)

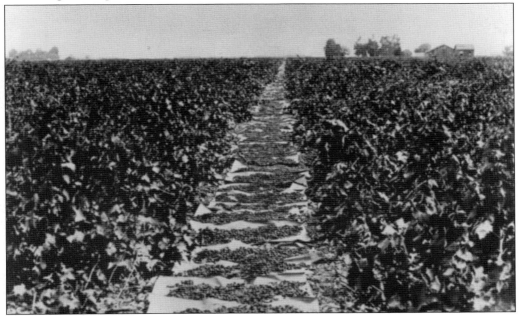

MAKING RAISINS. Grapes were especially well suited for dry ranching, which means irrigation was not used. Grapevines can extend their roots more than 20 feet down through the sandy soil to reach underground water. Pictured are muscat grapes being dried in the sunshine. Lying low on the ground protected the raisins from the strong canyon winds.

THE BECKLEY HOUSE.
Charles Beckley
came to Upland from
Kansas as a young
man with his parents,
brothers, and sister in
1900. In 1902, he and
his brother bought a
10-acre ranch on the
southeast corner of
Hermosa Avenue and
Nineteenth Street
in Ioamosa. He grew
Valencia and Navel
oranges on his ranch
and also looked
after the next-door
groves owned by the
Albert family. Like
many families in
town, they helped in
hauling rocks down
from the canyons
to build the stone
church on Archibald
Avenue. The five
acres on the corner
were sold in 1934
to the Fifields, who
built the two-story
stucco and rock
house pictured here.
This beautiful home
is now the clubhouse
for the Valencia
Commons Retirement
Community, so
named for the
Valencia oranges
once grown there.
(Dawn Collins.)

31

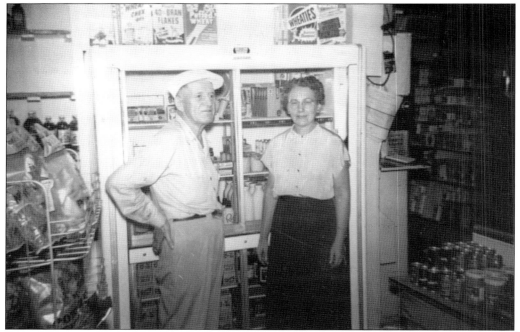

BILLINGS GROCERY. Gordon and Hazel Billings opened a grocery store on Amethyst Avenue in 1922. Amethyst Avenue was the business center for early Alta Loma. Ranchers would place their order by phone, and Billings would deliver it. Their son Gene would barbecue ribs, burgers, and hot dogs so that the workers in the area could buy a hot lunch. (Esther Billings.)

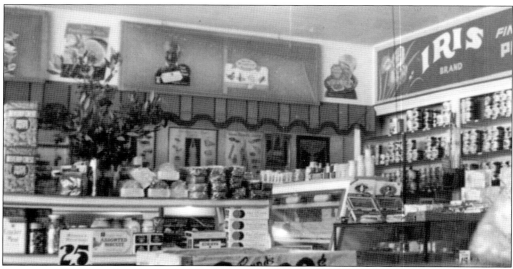

INSIDE THE BILLINGS STORE, 1937. A small market had to carry a little of everything that the local families needed. During busy smudging time in winter, the store sold the three Bs: beans, bread, and Boroxo, a powdered hand soap. Simple basic foods were needed for the tired smudgers who stayed up all night to light the oil pots. Boroxo soap was used to clean off the soot that covered everything and everyone. (Esther Billings.)

BABY BILLINGS. The town has changed, but children haven't. The freshly washed baby, Eugene Billings, pictured here was born in Cucamonga but spent the majority of his life in Alta Loma. In Cucamonga, his family lived across from the stone church, and he apparently had baths outside in the washtub. Gene Billings grew up to be a war veteran, fire chief for the Alta Loma Fire Department, and a volunteer to the community for various issues, as well as second-generation proprietor of the Billings Market. (Esther Billings.)

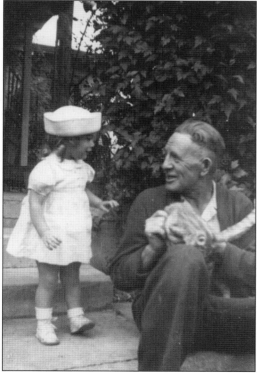

YOUNG AND OLD, 1948. Lynette Billings and grandpa Gordon Billings encapsulate the small-town feel of the time when everyone knew everyone else. Lynette tries on grandpa's sailor hat and looks like she stepped out of a Shirley Temple movie. Gordon always wore that hat while working the meat counter in the market. Perhaps grandpa would take her across to the malt shop for an ice cream. (Esther Billings.)

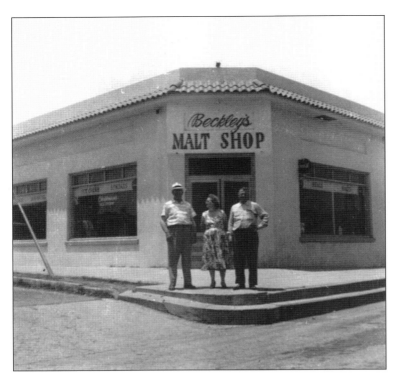

MALT SHOP. Young and old could enjoy a cold drink or malt at the Albert building erected in 1926 on Amethyst Avenue. It was across the street from the market and the fire station. The uniquely shaped corner building has been home to a drugstore, post office, malt shop, beauty shop, and Dr. Strange's record store. (Nancy Westenhaver.)

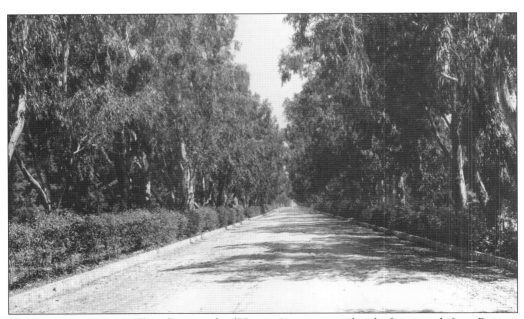

HAVEN AVENUE, 1925. This photograph of Haven Avenue was taken looking north from Banyan Street. Haven Avenue was originally lined with cedars, but they required too much watering. These eucalyptuses replaced the cedars to create a majestic boulevard. Haven Avenue has since been widened, and most of the trees were removed and replaced with alternative landscaping.

FIREFIGHTER, C. 1920 TO 1930. Fire is a constant danger when living near the dry San Gabriel Mountains. Communities had to look after themselves and provide their own fire coverage. A volunteer firefighter mans the pumper truck, sending water through three hoses to other volunteers fighting a nearby fire. (Rancho Cucamonga Fire Department.)

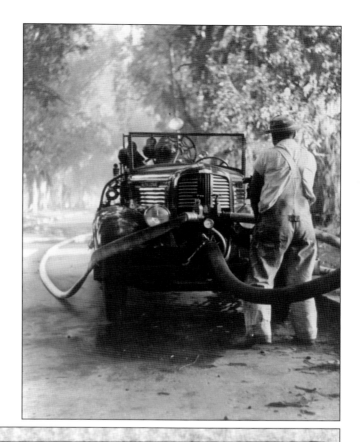

GRAND OPENING

of the new
ALTA LOMA FIRE HALL

DINNER and DANCE
$1.00 Per Person

TUESDAY, JUNE 14, 1938

DINNER SERVED PROMPTLY AT 7 P.M. DANCING AT 9

FIRE HALL DANCE TICKET, 1938. Having a volunteer fire department meant the community had to foot the bill to purchase the town's fire equipment and engines. Fire hall dances were a popular way to have some fun and raise the needed funds for engines and equipment. Ladies' organizations would plan the events, make the food, and sell the tickets. (Esther Billings.)

WOMAN'S CLUB PRESIDENT, 1910. Gertrude Reed was the first secretary of the Cucamonga Woman's Club. The following year, she was elected as the club's second president. First organized as the Cucamonga Woman's Club in 1909, it later became the Alta Loma Cucamonga Woman's Club and today is the Rancho Cucamonga Woman's Club. For over a hundred years, its women have dedicated themselves to improving their city and helping those in need. (Rancho Cucamonga Woman's Club.)

FIRE ENGINES, SEPTEMBER 1971. Eventually, Alta Loma contracted with the county to fund the fire department through taxes. Pictured is the old fire station that is now a residence. The new fire station, farther north on Amethyst Avenue, was built to accommodate the taller and wider, modern fire engines and trucks. (Esther Billings.)

CHURCH LADIES. All three Cucamonga communities had to be self-sufficient, relying heavily on volunteer work. Ladies' groups were often responsible for organizing community work and activities. The back of this photograph listed these volunteers' names; pictured from left to right are (first row) Lillian Rupp, Myrtle Hatch Joseph, Geneva Caps, Mrs. Peter Smith, and Sadie Smith; (second row) Mrs. Frank Hedges, Mary Bell Rupp, and Sarah Dixon; (third row) Mrs. Gastner, Stella Billings, Carrie Smith, Mrs. Brown, Mrs. Haddock, and Mrs. Hatch. (Esther Billings.)

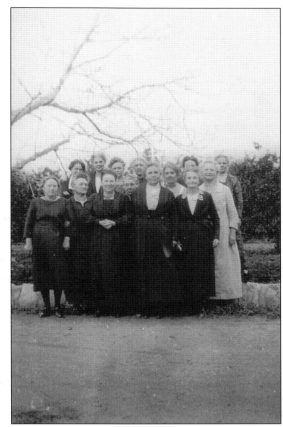

HONOR ROLL, JANUARY 5, 1951. The Community Club first sponsored the Honor Roll in 1942. This photograph was taken in 1951, when the third panel was dedicated. A gold star by the name denotes someone killed in action. Those pictured here, from left to right, are Ray Derfer, Herbie Blake, Bill Billesbach, Mr. Thom, Art Allen, Herb Hall, George Smith, Rev. Ray Wirth, Bill Buttery, Gordon Billings, Mr. Yopp, Lew Gilbert, and Sheriff Asgar Ravn. (Esther Billings.)

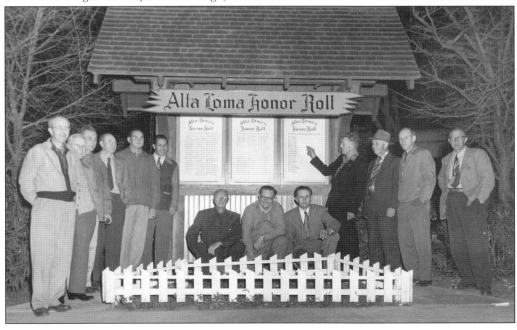

ISAAC LORD. Lord is best known for founding the town of Lordsburg, which later became the town of La Verne. He built the immense Lordsburg Hotel. Before it was ever opened for customers, Lord donated it to serve as a college, and it is now LaVerne College. Lord was a San Bernadino County superintendent who was influential in getting railroads built and roads improved. (Luana Hernandez.)

LORD HOUSE'S FRONT PORCH, c. 1960. Isaac Lord came to Ioamosa in 1885 with his wife, Julia Lord. They added a large house in front of a three-room bungalow situated on a 10-acre parcel facing Hellman Avenue. It continues to be a private residence. (Luana Hernandez.)

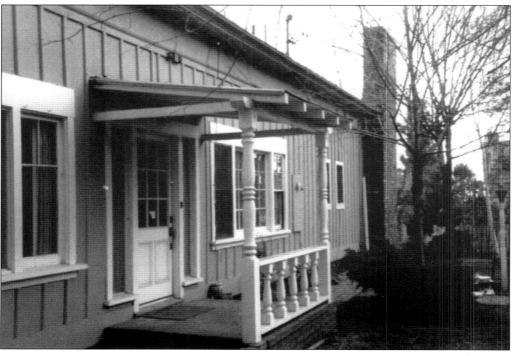

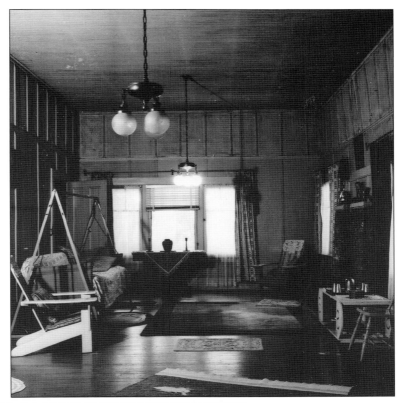

LORD HOUSE, C. 1960. Pictured at right is the Lord House living room, and below is a bedroom. The paneled walls and hardwood floors have been retained by the different owners over the years. Lord and his family were members of the Church of the Brethren and were interested in starting a Brethren colony in the area. (Both, Luana Hernandez.)

MARY ALBERT AND THE ALBERT HOUSE. Mary Albert and her cat pose by the front porch of her parent's home. The Albert family owned land and buildings around Alta Loma. The Albert family first came to Ioamosa in 1895. This house was built in 1906. Henry Albert first grew olives, figs, peaches, and prunes on his 60 acres of land. In 1911, he sold half his land and grew only navel oranges. Albert served on the committee to bring the railroad through the town. (Both, Cooper Museum.)

Three

CUCAMONGA

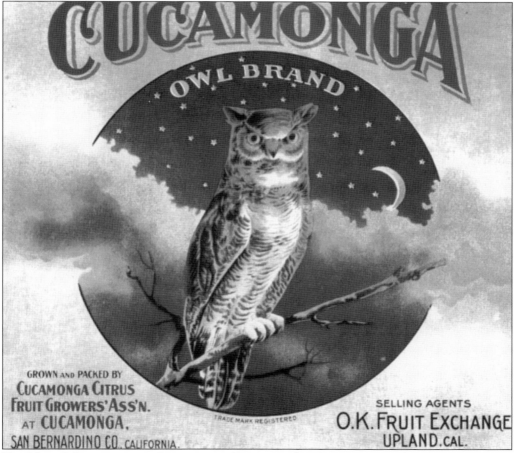

THE MANY MISSPELLINGS OF CUCAMONGA. Cucamongabit, Coco Mango, Pokamonga, Comingo, Cocomonga, Cuca Creek, Cucmonga, and Cocomingu are some of the creative spellings used in the diaries of explorers and forty-niners who stopped at the refreshing waters of Cucamonga. (Author's collection.)

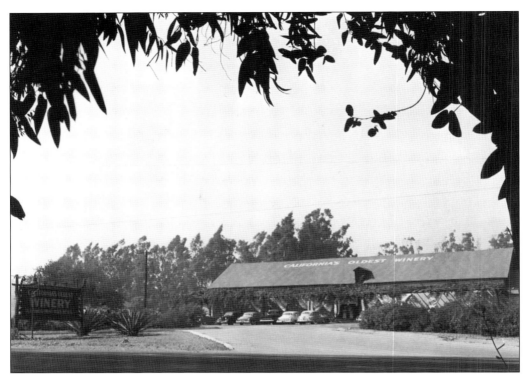

THOMAS WINERY. Cucamonga began here. This location has been the site of a vineyard and winery since 1838, when Tiburcio Tapia founded the Cucamonga Rancho. The Thomas brothers bought the property from Isaias Hellman. Owners since that time have kept the name. Thomas winery is the oldest winery in California and the second oldest in the United States.

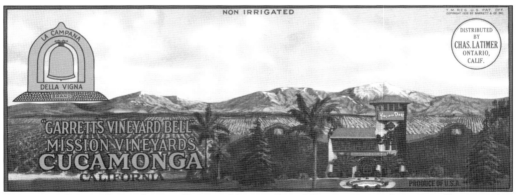

GARRETT'S GRAPE CRATE LABEL. Garrett's Virginia Dare Winery is now a business office complex at the corner of Haven Avenue and Foothill Boulevard. Its beautiful Mission-style architecture made it a favorite local landmark.

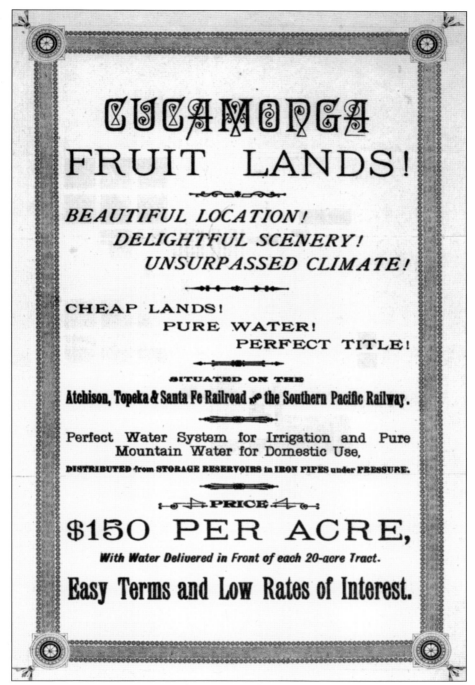

CUCAMONGA FRUIT LANDS VERSO. Advertisements like these were often sent in letters to friends and relatives back home to encourage them to move to Cucamonga. Cucamonga Fruit Lands and Cucamonga Homestead were two parcels that Hellman kept to sell after purchasing the entire 13,000 acres of the rancho. Hellman was a major investor behind Southern California development projects. (Model Colony Room.)

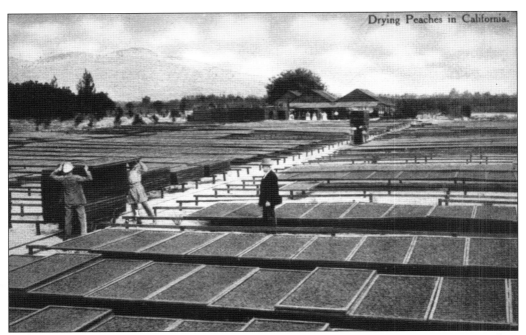

DRYING PEACHES. This California postcard depicts a scene that was once more common than orange groves in Cucamonga. Many of the area's first fruit orchards were peaches and apricots. Peaches have a short shelf life and, therefore, needed to be canned or dried before being shipped long distances or stored in the family fruit cellar. (Model Colony Room.)

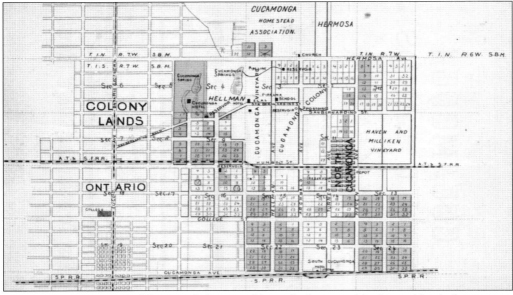

COLONIES MAP, C. 1870S. Hermosa Colony would one day become Alta Loma. North Cucamonga would be called North Town before it would eventually disappear from the map. North and South Cucamonga would make up the Cucamonga School District. Archbald Avenue was named after landowner John Archbald, later becoming Archibald Avenue. The larger springs in the center of the map are in the area of today's Red Hill Park. (Model Colony Room.)

NORTH TOWN CHILDREN, C. 1950.
Shirley Stipe, too young for school, poses with North Town children on their way home from school. Every day, the children would pass her house on Eighth Street. A few years later, she joined them at the school on South Archibald Avenue. (Shirley O'Morrow.)

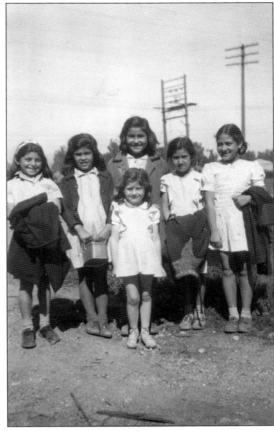

CUCAMONGA'S CHINATOWN. The Chinese lived in their own community west of Archibald Avenue, between Foothill Boulevard and San Bernardino Road. After a fire destroyed most of their wooden houses, the Araiza family built this brick building for them. As agriculture jobs diminished, the Chinese left. Sadly, this building is on its last legs. (Dawn Collins.)

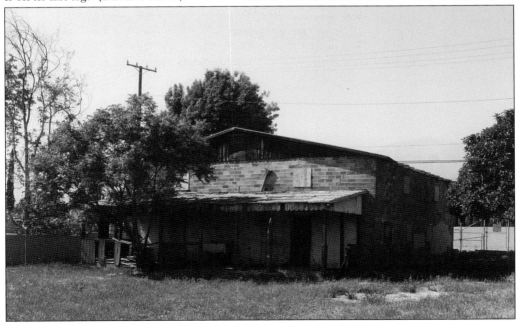

CENTRAL ELEMENTARY SCHOOL, C. 1920S. Central School students pose in front of their new concrete school building on the corner of Hellman Avenue and San Bernardino Road. No longer a public school, it is now called Sweeten Hall. This Mission-style school design was popular

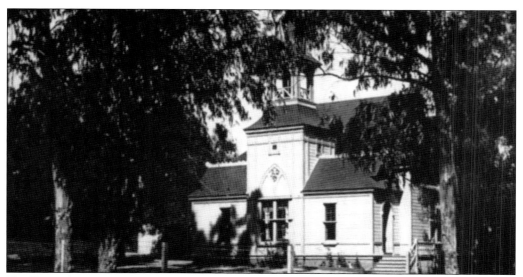

THE FIRST CENTRAL ELEMENTARY. This was the original school at the corner of Hellman Avenue and San Bernardino Road. At the time, it was common to replace wooden schools with durable concrete buildings that could more likely withstand wind and fire.

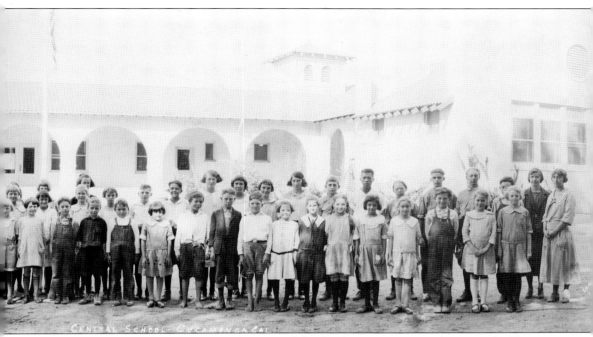

throughout Southern California. At the time of this book's writing, it was home to the Kaiser Steel Museum. (Central School District.)

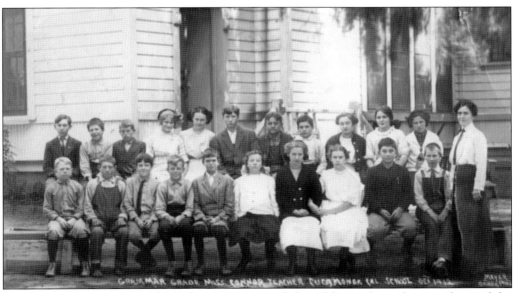

GRAMMAR CLASS OF 1912. Miss Connor poses with her older grade students in front of the original Cucamonga schoolhouse. As the population grew, a second school was built on Archibald Avenue south of Eighth Street.

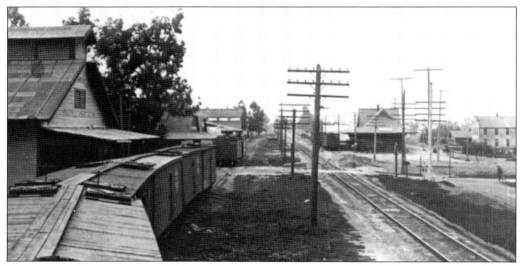

CUCAMONGA PACKINGHOUSE. This packinghouse was located on Eighth Street, east of Archibald Avenue. Grapes, citrus, and fresh and canned fruit were shipped to market from here. The train depot is seen on the right.

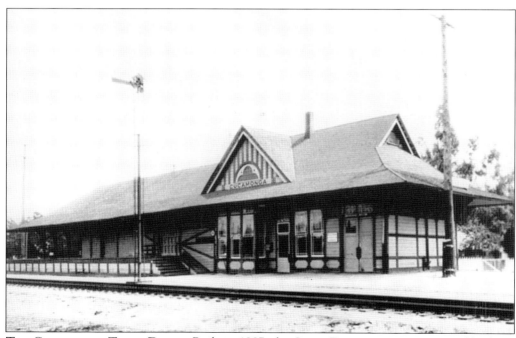

THE CUCAMONGA TRAIN DEPOT. Built in 1887, the Santa Fe train station was used by both Cucamonga and Ioamosa farmers until the Alta Loma station was built. It was no longer needed when the citrus and grape industry left Cucamonga. (Ed Dietl.)

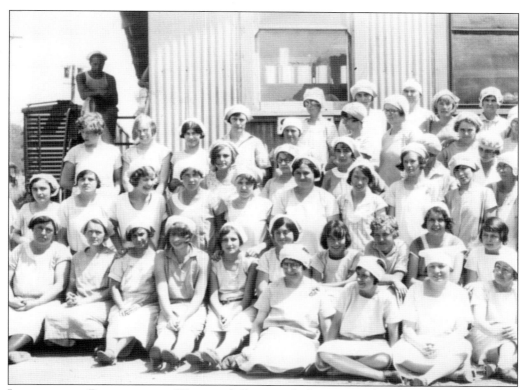

LADIES OF THE PACKINGHOUSE. Women of all ages picked up seasonal work at the canneries and packinghouses. This picture was taken during the warm summer or fall harvest of what could have been oranges, peaches, or grapes.

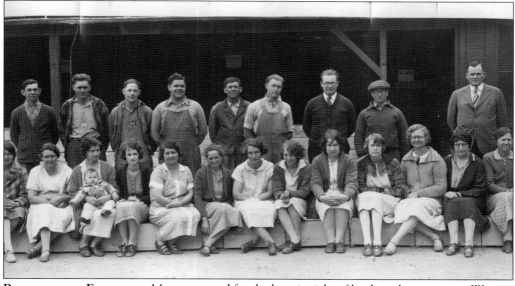

PACKINGHOUSE EMPLOYEES. Men were used for the heavier jobs of loading the train cars. Women typically graded, wrapped, and packed the fruit. These workers may have been sorting the winter harvest of lemons.

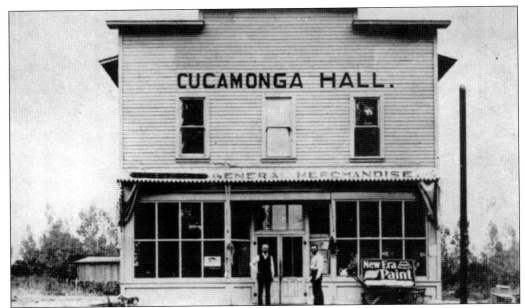

CUCAMONGA HALL AND STORE. Loyal, Joe, and their parents came to Cucamonga from Pennsylvania. The Strieby Brothers Store was located on the east side of Archibald Avenue and north of Foothill Boulevard. The original store is gone, but the location is still a shopping center. The Strieby home still stands at San Bernardino Road and Hellman Avenue across from Sweeten Hall.

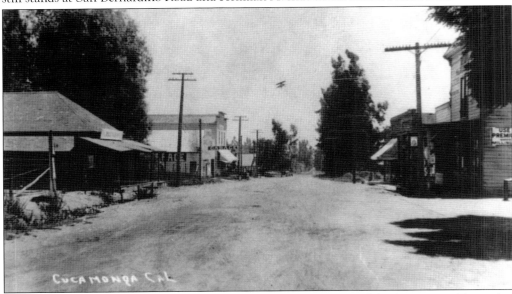

ARCHIBALD AVENUE, C. 1910. According to the July 12, 1967, issue of the *Cucamonga Times*, this view looking south on Archibald Avenue shows: the first store on the right was the Lucas-Williams Grocery and Hardware Store; the building beyond it, with the awning, was the Lucas-Williams Dry Goods Store; between the two was the Ownings Pool Room and Barber Shop; south of the dry goods store were Benneson and Treanor Drug Store and the post office; the first building on the left was the Jones Restaurant; and beyond that is believed to be the Ledig Garage. Farther down would be the train tracks and depot.

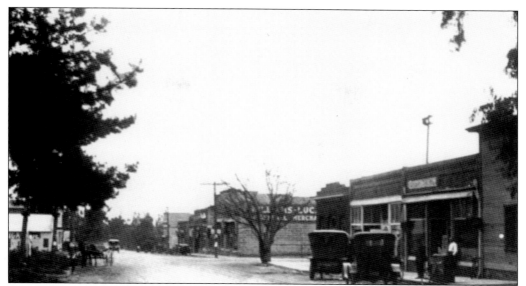

ARCHIBALD AVENUE, C. 1920. The Lucas Williams Grocery Store has been moved and was replaced by the post office. The dry goods store no longer has an awning, but Williams Lucas General Merchandise can be seen painted on its sidewall through the tree branches. The street behind the tree may be Foothill Boulevard. More cars than horses share the dirt roads.

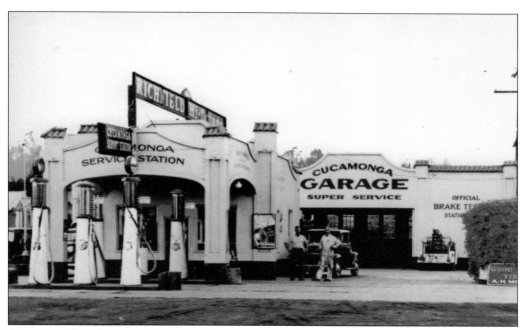

RICHFIELD GAS STATION, FOOTHILL BOULEVARD. Today, only the flat roof canopy that covers the pump area remains of Richfield gas station, which stands on Foothill Boulevard and west of Archibald Avenue. The gas station was built in 1914 and operated until 1972. Its Mission-style and Spanish Colonial architecture made it a roadside beauty on Route 66. (Shirley O'Morrow and Ed Dietl.)

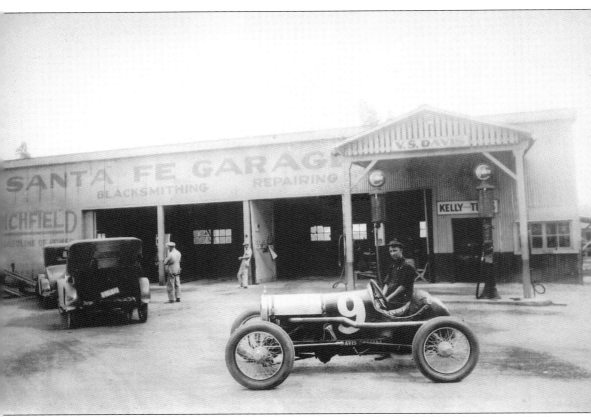

SANTA FE GAS STATION. Virgil Davis operated two garages: the Richfield and the Santa Fe. In those early days, a mechanic offered not only automobile, bicycle, and motorcycle repairs but also blacksmithing for horses. Decades later, the Richfield gas station would be known as Atlantic Richfield Company (ARCO). (Shirley O'Morrow and Ed Dietl.)

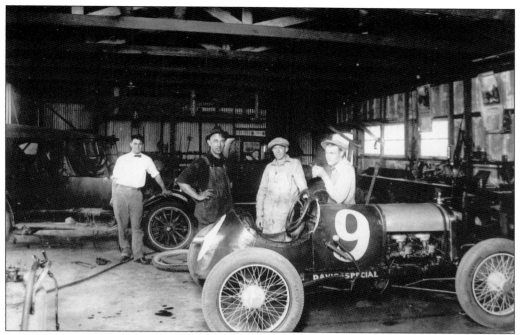

No. 9 Race Car. Inside the Santa Fe gas station's garage, Virgil Davis (white overalls and touring cap) built his No. 9 Davis Special from the ground up. Davis drove No. 9 in races and had great hopes of making it to the Indie 500 in his homemade car, but it never came to be. His friend Ancil Morris stands next to him, on left. (Shirley O'Morrow and Ed Dietl.)

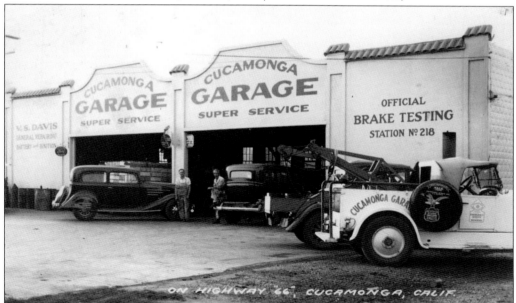

Cucamonga Garage Postcard. This mechanic's garage stood behind the Richfield gas station and was also operated by Virgil Davis. Its Mission Revival–style roofline made it a beautiful Route 66 showpiece. It remained practically unchanged through the years. Unfortunately, the mechanic's building fell down in January 2011 after heavy rains. (Shirley O'Morrow and Ed Dietl.)

BOY SCOUT PARADE, 1982. Boy Scouts parade south down Archibald Avenue, representing the newly incorporated city in possibly an early Founder's Day Parade. Rancho Cucamonga maintains its small-town roots by hosting its yearly Founder's Day Parade featuring school, scout, and civic groups.

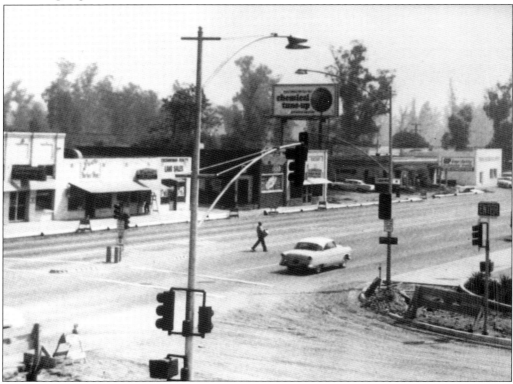

STOPLIGHTS ARRIVE, c. 1960. Traffic lights, sidewalks, and curbs are being installed at the Archibald Avenue and Foothill Boulevard intersection. The old dirt road became a modern paved thoroughfare complete with traffic signals. The building on the facing corner still exists. (Ed Dietl.)

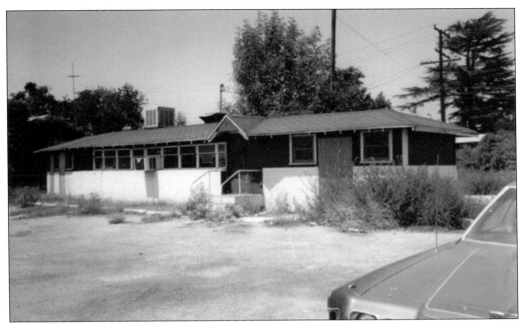

DOLLY'S DINER. On the west side of the Richfield gas station was a popular small eatery called Dolly's Diner. It closed in the 1970s but briefly enjoyed a comeback in the 1980s for a few weeks as the location set of B movie *Big, Bad Mama*, starring Angie Dickenson and William Shatner. (Ed Dietl.)

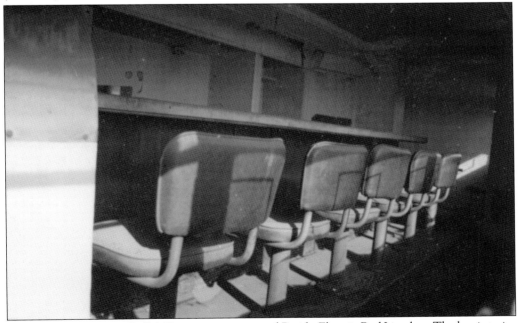

INSIDE DOLLY'S DINER. Dolly's Diner was a converted Pacific Electric Red Line bus. The bus interior had a counter, with stools and a few small tables by the windows. The kitchen and restrooms were outside in the small building to the right. Later, the owner erected the block building around the bus. It was torn down in the 1990s.

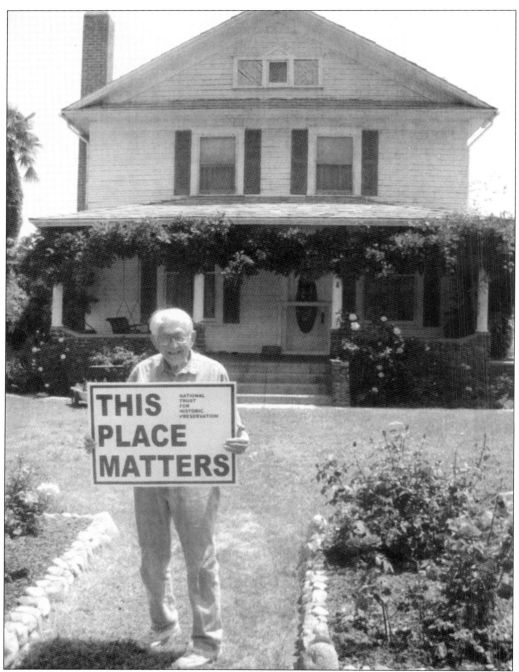

THE EMERY HOUSE. Built in 1908 on Archibald Avenue and south of Baseline Avenue, the Emery House was a 10-acre citrus ranch that included its own sorting and packing barn. Its orange groves were maintained until about 1970. It is believed to be a Sears, Roebuck and Co. catalog house that came in prefabricated pieces by train and was then assembled by Klusman Construction. Ralph Strane, owner of the house for many years, stands with a sign to remind people to preserve history and create historical landmarks in Rancho Cucamonga. (Ed Dietl.)

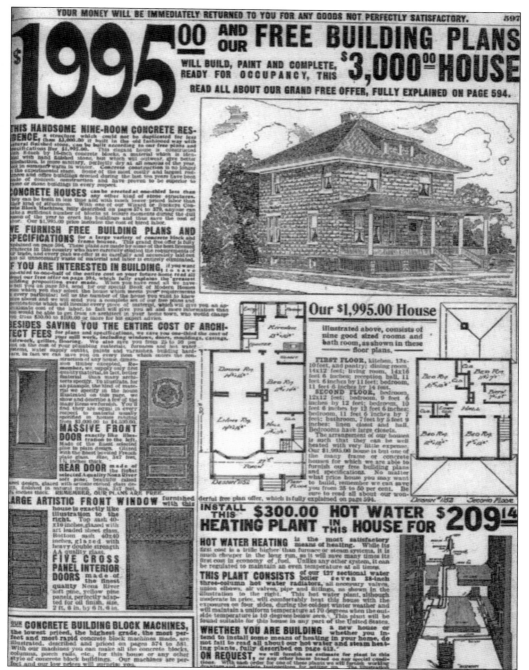

SEARS, ROEBUCK AND CO. CATALOG HOUSE. Build a $3,000 house for $1,999. Just about anything could be ordered from the Sears, Roebuck and Co. catalog, even a house. Customers had several models from which to choose. Precut lumber, doors, windows, and everything else needed to build a complete house arrived by train. A Sears catalog with this page was found in the attic of the Emery house, leading historians to believe it was a kit house or at least designed after one. (Ed Dietl.)

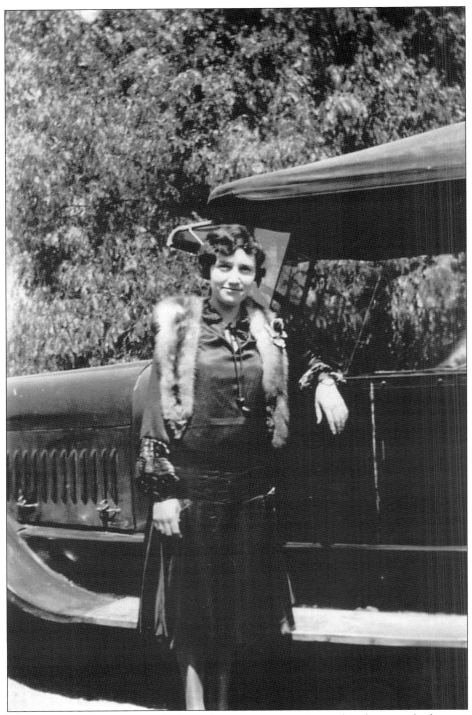

LENA STIPE, C. 1930S. Getting all dressed up was an occasion to be photographed, especially during the Depression. Stipe models her fashionable outfit, complete with a fur stole, in front of the Virginia Dare Winery. (Shirley O'Morrow.)

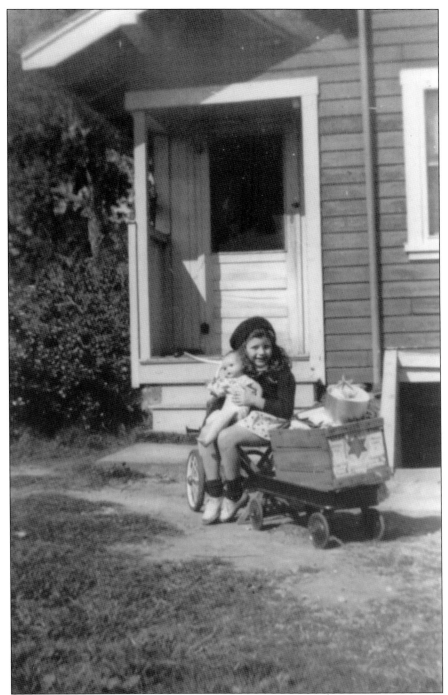

Shirley Stipe, c. 1940s. American citizens were urged to do their part to help the war effort by collecting cans during World War II. The scrap metal went towards building military items, such as tanks and planes. Young Shirley poses with her doll Annie outside her back door after collecting cans and scrap metal from her neighbors. (Shirley O'Morrow.)

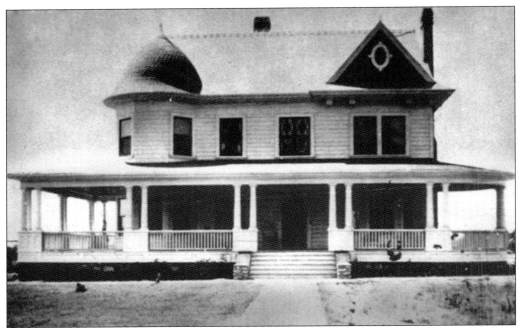

CHRISTMAS HOUSE, 1904. The H.D. Cousins house, a Queen Anne Victorian home, was built in 1904. It earned the nickname "the Christmas House" for the red-and-green, stained-glass windows in its turrets and the elaborate holiday parties held by the Whitsons, who were the owners from 1910 to 1977. The formal dining room used for the lavish entertaining shows off the beautiful brick and carved-wood fireplace and décor of the time. Today, it is a bed-and-breakfast. (Above, Ed Dietl; below, Cooper Museum.)

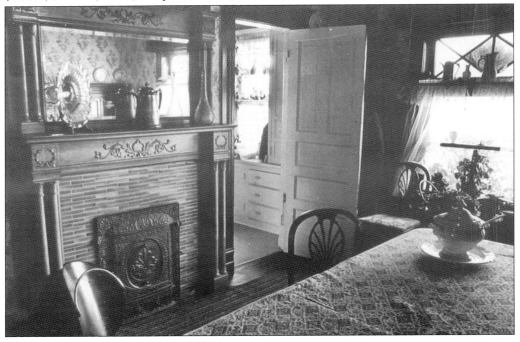

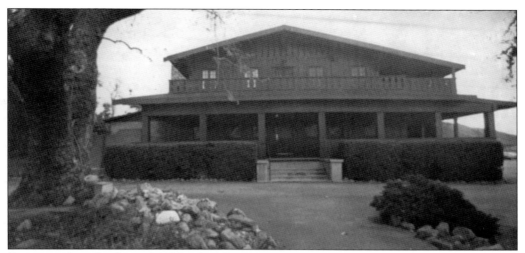

SYCAMORE INN. In the mid-1800s, the Mountain View Inn was a Butterfield Stage stop on the Santa Fe Trail. Its proprietor, Bill "Uncle Billy" Rubottom, is credited with saving Doña Merced's life by creatively disarming the lynch mob as they met for drinks at his inn beforehand. In the 1920s, John Klusman built the current building (above) in an old-world style similar to that of his native Germany. The sycamore grove behind the inn is reminiscent of how the entire Bear Gulch area originally appeared. The Sycamore Inn continues to offer fine dining.

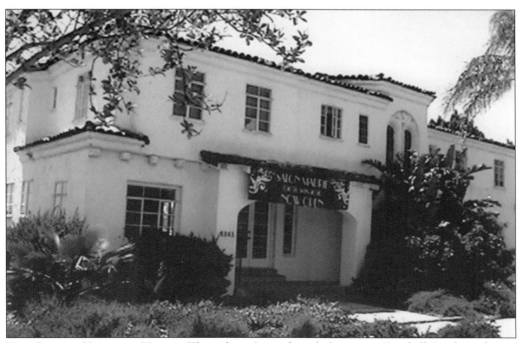

THE GEORGE KLUSMAN HOUSE. This white Spanish-style home on Foothill Boulevard near Vineyard Avenue was designed in 1928 by Allison and Allison, who also designed the campus of the University of California, Los Angeles. Klusman was a German emigrant who came to Cucamonga with his brothers John and Henry in 1894. The Klusman brothers were successful businessmen who erected many buildings in the area. (Author's collection.)

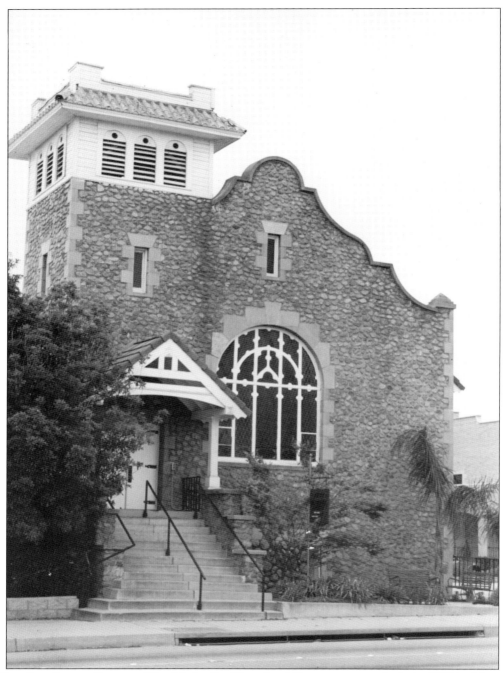

THE OLD STONE CHURCH. The Methodist Church of Cucamonga was built in 1907 by Henry Klusman and community volunteers. The church's first two wooden structures were blown down by fierce windstorms common to the area. This third church building with its 18-inch-thick walls has successfully withstood storms for over 100 years. The men of the community took horse-drawn wagons up into the local canyons, and it is said they gathered 337 wagonloads of rocks construct the two-story church at a cost of about $7,000. (Esther Billings.)

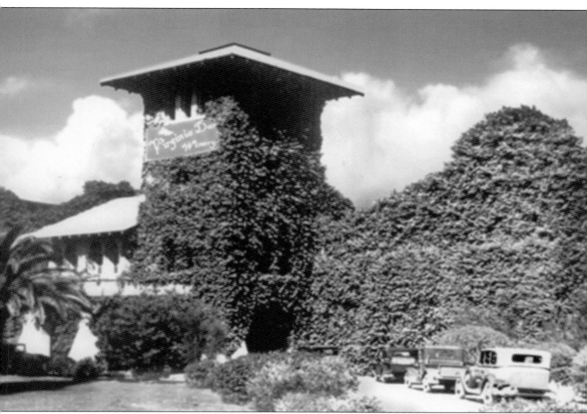

VIRGINIA DARE WINERY. German emigrant John Klusman purchased $1,000 acres of wildland and planted vineyards. With business partner Morton Post, he built the winery in 1910. Klusman sold it to Garrett and Company in 1917, just before Prohibition took effect. Klusman was also president of the Cucamonga Building and Loan and director of the Cucamonga Water Company. The winery's architectural design was inspired by Riverside's majestic Mission Inn.

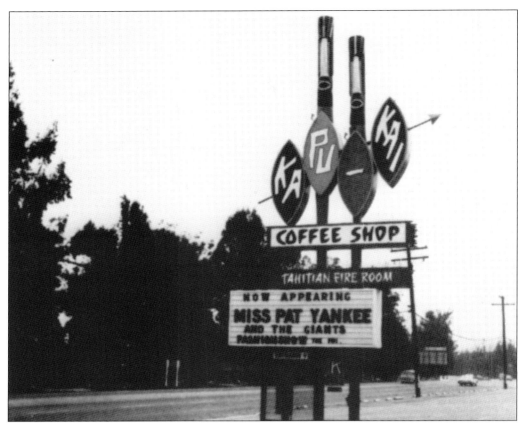

KaPu-Kai Coffee Shop and Tahitian Fire Room, 1964. The popular Polynesian-themed restaurant and nightclub was a favorite eatery and entertainment place. It had a coffee shop, banquet room, and a nightclub, and each one was unusually and beautifully decorated. It was located on the northwest corner of Foothill Boulevard and Vineyard Avenue. Sadly, it and the bowling alley behind were destroyed in the 1969 flood. (Alta Loma High School.)

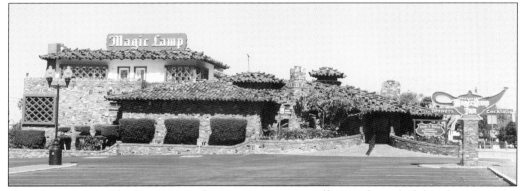

The Magic Lamp. The Magic Lamp Restaurant was originally a modern, sleek-lined, rectangular building called Lucy and John's Restaurant. In 1947, patrons could get a five-course dinner for $2. In the 1950s, it was remodeled with beautiful brickwork and a layered tiled roof. Eye-catching or fanciful design epitomized the Route 66 architecture in the highway's heyday. This roadside landmark still offers fine dining today. (Dawn Collins.)

Four

ETIWANDA

ORIGIN OF ETIWANDA'S NAME. George Chaffey named his new colony Etiwanda after an Algonquin Indian chief who was an old friend of the Chaffey family in Ontario, Canada. Chaffey named his other colony Ontario. Many of the Chaffey family's Canadian friends and family made the move to sunny California. (Author's collection.)

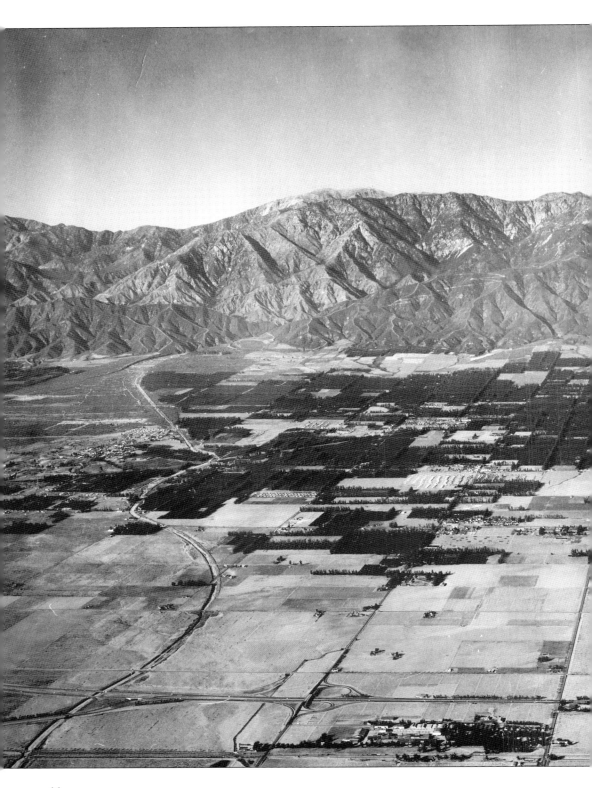

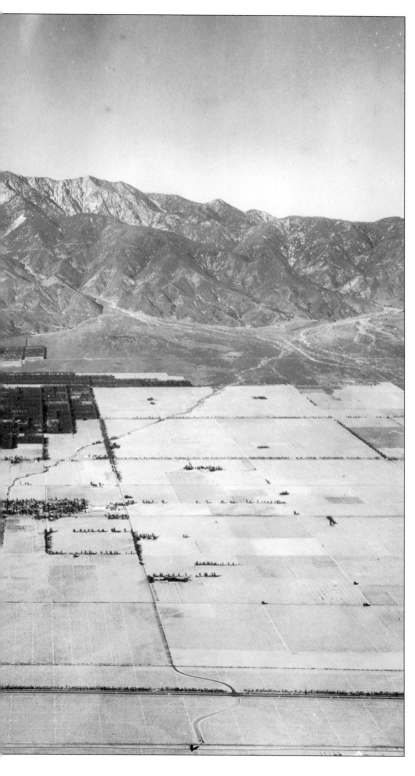

1958 AERIAL PHOTOGRAPH. This 1958 aerial view shows the Cucamonga wash on the left and Day and Deer Creeks on the right. The Guasti Winery, at the very bottom of the photograph, was originally part of Cucamonga. On the left side of Guasti is Archibald Avenue; on the right is Haven Avenue. Near the top of Haven Avenue is the empty land that would become Chaffey College in two years. The long windrows of tall eucalyptus trees lined major streets and divided properties. Much of Etiwanda was still open land, its population remained steady at 1,000 until the late 1900s, when it finally topped 2,000 people and the building boom began. The majestic San Gabriel Mountains were once part of the Sierra Nevada Range, according to geologists and biologists. It is one of the few transverse ranges in the world. Tectonic movement has pushed what used to be the southern portion of the Sierra Nevada Mountains from a north-south position to an east-west position. (Chaffey College.)

WILLIAM BENJAMIN CHAFFEY. William Chaffey moved his family to California at his brother's urging. George was excited about the business possibilities available there. William had studied horticulture and determined the soil of the Cucamonga Plain would be wonderful for growing fruit trees. The Chaffey brothers developed irrigation colonies named Etiwanda and Ontario. (Model Colony Room.)

F. H. ROGERS & CO., PHOTOGRAPHERS.
624 SAN FERNANDO ST., LOS ANGELES, CAL.

GEORGE CHAFFEY. In 1880, George Chaffey and his family visited his retired parents in San Bernardino. Excited about the investment possibilities, he convinced his younger brother William to move to California. The two of them bought land and created two colonies, Etiwanda and Ontario. George Chaffey, ever the inventive engineer, built a concrete water pipe system to deliver water to the highest corner of each 10-acre parcel, an innovative move in that day. This worked so well that he went on to plan water systems for cities around Southern California and Australia. (Model Colony Room.)

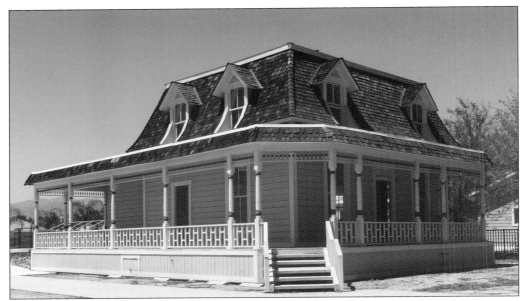

THE CHAFFEY-ISLE HOUSE. George Chaffey built this house for his mother, Anne Chaffey, and his younger sister Emma in March 1883. It is an excellent example of the Second Empire style of architecture during the 1880s, and it was built with a rare mansard roof. After Chaffey left for Australia in 1886, the house was bought by James C. Isle. He had the house moved on log rollers to its present location in the Etiwanda Historic District. (Dawn Collins.)

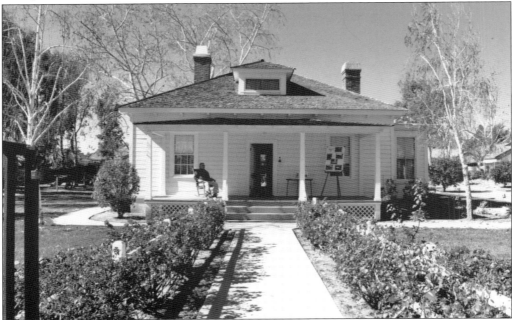

CHAFFEY/GARCIA HOUSE. George Chaffey lived in this house that he bought from Captain Garcia. George Chaffey, the engineer, wired his house and had Etiwanda's first electric light in 1882. To power that light, he built the first hydroelectric dynamo in the western United States. (Kelly Zackmann.)

COLONIES ADVERTISING BOOKLET, C. 1885. In this booklet, Chaffey wrote glowingly about the "opportunities of investments equally inviting for both the man of moderate means and the capitalist." Chaffey knew the allure of warm winters appealed greatly to those in the northern states and Canada, and he used it in his sales pitch: "What better could be offered to one seeking a home in balmy California under sunny skies of Sunny California?". Chaffey convinced many people to move thousands of miles and buy land in his model colonies in sunny Etiwanda and Ontario. (Cooper Museum.)

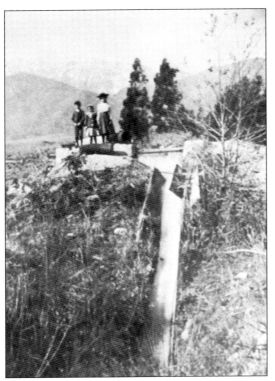

ETIWANDA WATER COMPANY SANDBOX. The Chaffeys also bought the land and water rights from George Day, pictured below, for Day and East Etiwanda Canyons. In the left photograph, children are shown at the Etiwanda Water Company sandbox at Twenty-fourth Street in 1909. In the photograph below, water was brought down in wooden flumes from Day Canyon to the distribution point called a sandbox. The water was then pumped through pipes to the highest corner of each 10-acre land parcel using hydroelectric dynamos built by George Chaffey. Valves to each parcel were turned on and off by a water master called a *zanjero*, who kept track of which ranches received their water on which day. (Below, Etiwanda Historical Society.)

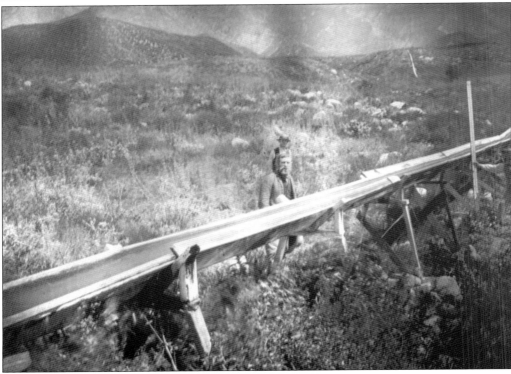

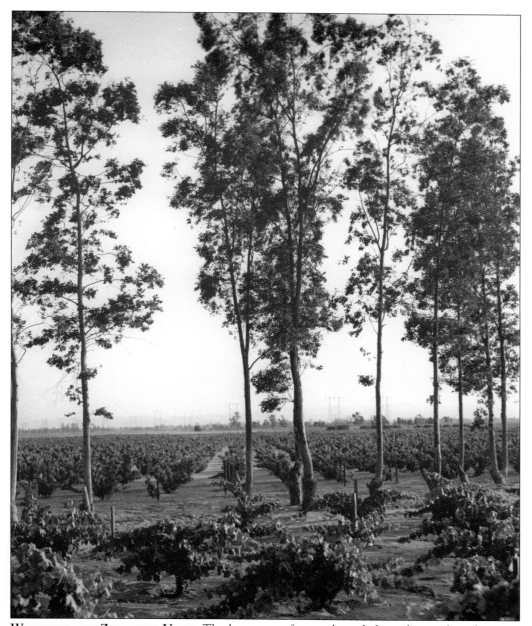

WINDROWS AND ZINFANDEL VINES. The long rows of trees planted along the north and eastern sides of the property provided windbreaks called windrows. Eucalyptus from Australia was used because it grew fast and could tolerate heat without much water. This windrow was planted to protect these zinfandel grapevines from the fierce winds that often plague Etiwanda.

THE ETIWANDA TELEPHONE. The Chaffeys brought telephone service to Etiwanda. By 1882, Etiwanda had the first long-distance telephone line in the world. The Chaffey's Home Telephone Company connected Etiwanda to Riverside, Redlands, and San Bernardino. George Chaffey then helped Los Angeles establish its long-distance telephone service. In 1883, the Chaffeys acquired the phone line that connected George Chaffey's Etiwanda home to Ontario and Los Angeles. The first Etiwanda telephones were in the Frost Brothers Store, the Electric Company, and the Chaffey house. In the summer of 1908, telephones were installed for public use. (Model Colony Room.)

ETIWANDA'S FIRST TELEPHONE OPERATOR. Seated in the chair is Etiwanda's first telephone operator, Florence Fisher. Standing next to her is her daughter Nellie Fisher. Fisher operated Etiwanda's first telephone exchange from her home on Etiwanda Avenue. The house has been relocated to the historical district next to Grapeland School. (Cooper Museum.)

LONG-DISTANCE TELEPHONE ADVERTISEMENT, 1955. Calling long distance once required the help of a telephone operator to manually connect the lines through a switchboard. This advertisement from the *Cucamonga Times* urges telephone customers to take advantage of the new direct-dial technology. Pretty much everywhere was long distance from Etiwanda. Before the 21st century, people mainly stayed in touch by mailing handwritten letters. (Esther Billings.)

when time means money...
use
LONG DISTANCE
and always call by number, it's even faster!

GENERAL **GENERAL TELEPHONE COMPANY**
SYSTEM **OF CALIFORNIA**
A Member of One of the Great Telephone Systems Serving America

ETIWANDA CONGREGATIONAL CHURCH. The Etiwanda Congregational Church was first organized on September 25, 1893. Worship services were held in the local schoolhouse until late in 1902, when the church was built. Its bell originally hung in the Grapeland School. There are a number of beautiful stained-glass windows. One is the George Chaffey Memorial Window honoring the good work he did for the Etiwanda and Ontario areas. (Dawn Collins.)

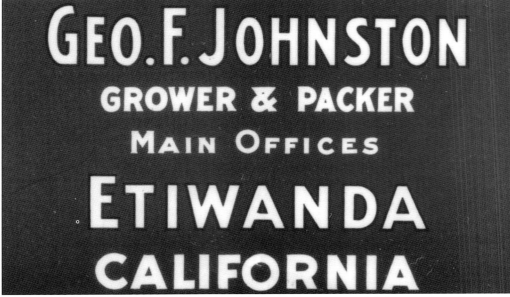

JOHNSTON GRAPES CRATE LABEL. George Johnston was a successful dry rancher who raised table grapes and raisins that were shipped across the South to the East and north into Canada. He is credited for developing a superior grape with another grower, William Thompson. That partnership resulted in the Thompson Seedless grapes that are still sold in grocery stores today. (Etiwanda Historical Society.)

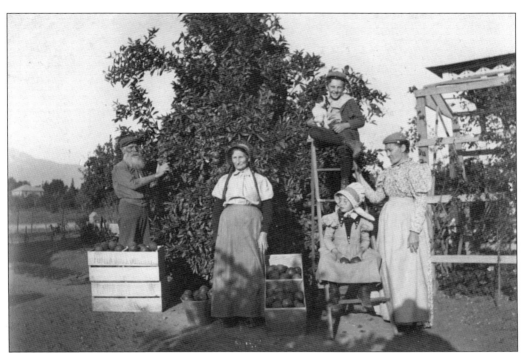

FAMILY PICKING FRUIT. A family and a Chinese woman, perhaps hired help of some kind, pose as they harvest a bountiful crop of citrus. The farm appears to be in the outer reaches of Etiwanda and southwest of the Cajon Pass. Agriculture reached its peak by World War II. When Kaiser Steel and other industries came into the region and supplied jobs, agriculture met its final decline. (Cooper Museum.)

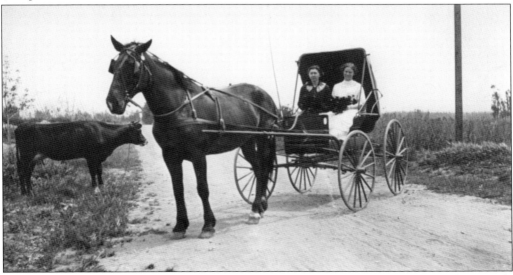

COW MEETS HORSE, C. 1890s. A loose cow says hello to some ladies enjoying a buggy ride somewhere in Etiwanda. Cattle and sheep ranching dwindled in place of crop farming. Though Basque shepherds on horseback could still be seen with their flocks in the vacant fields of Etiwanda and Cucamonga as late as the 1990s. (Cooper Museum.)

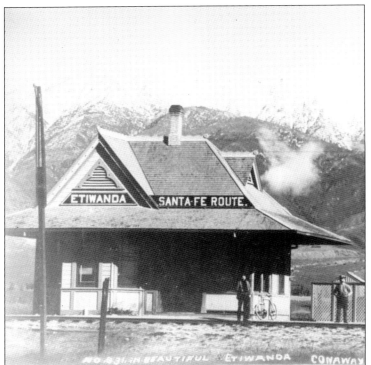

Santa Fe Depot. The Santa Fe Railroad first furnished public transportation for the Cucamonga region. Freight trains were needed to take heavy citrus and other perishable fruits quickly to market in Los Angeles and beyond. Next door to the depot was the packinghouse. (Model Colony Room.)

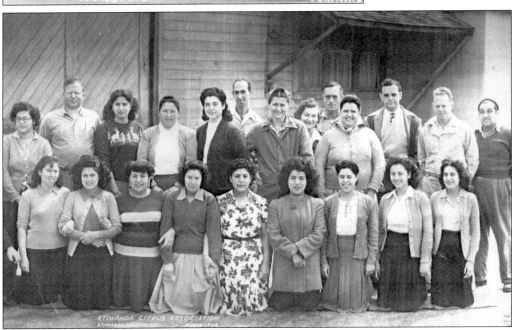

Etiwanda Packinghouse Employees. This 1948 photograph of the Etiwanda Packinghouse workers shows a sample of the postwar hair and clothing styles. The three ladies on the right side of the front row are, from left to right, Antonia Bermudez, Connie Bermudez, and Nettie Mena. (Mary Bermudez, Etiwanda Historical Society.)

PACKINGHOUSE. The first settlers had to develop their towns themselves. In addition to building schools and churches, they organized dried fruit associations to prepare and market their apricots, peaches, and muscat grapes. Next came a citrus fruit packinghouse to prepare and ship oranges and lemons by railroad. (Model Colony Room.)

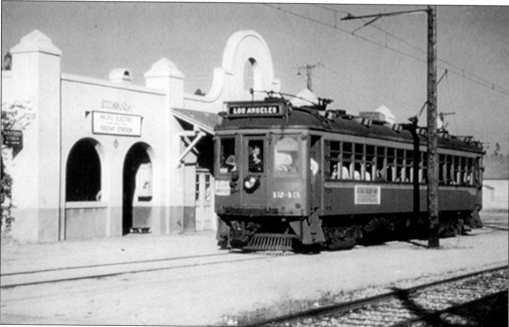

RED LINE TRAIN. In 1914, the Pacific Electric Railroad ran tracks into Etiwanda and adjoining communities. Young people could then ride to Chaffey High School in Ontario. Prior to that time, most young people did not attend school past the eighth grade because of the lack of transportation. Residents could take the Red Line to shop in Upland, to the San Antonio hospital, or even to business school in Los Angeles. This station is located in the Etiwanda Historical District.

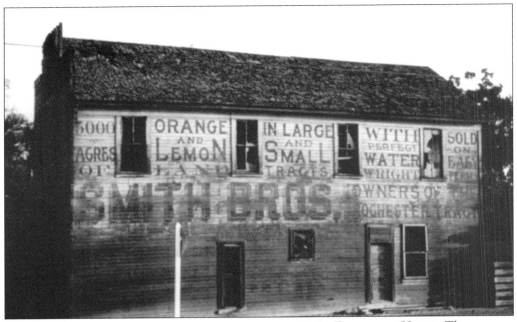

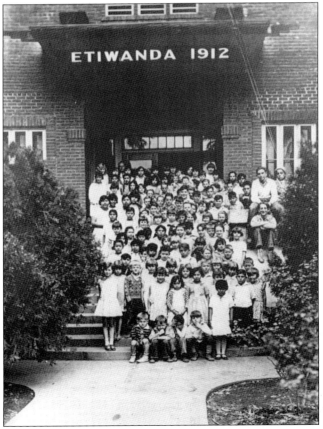

ROCHESTER HOTEL. The colony of Rochester was a failed development attempt. The Smith brothers advertised their real estate on the side of the hotel, promising land, water, and housing. The housing and store were both inside the hotel. The water was the spigot on the other side of the road. What remains of this venture is Rochester Avenue, where today's Epicenter Stadium is located.

ETIWANDA SCHOOL, 1928. As Etiwanda's population grew, so did its school. The two-room school was torn down, and this four-room brick school was built in 1912. In 1938, a modern school was built and later became Etiwanda Intermediate School. This photograph shows pre-Depression prosperity. Though not wealthy, the children wear new shoes and clothes for the occasion. (Etiwanda Historical Society.)

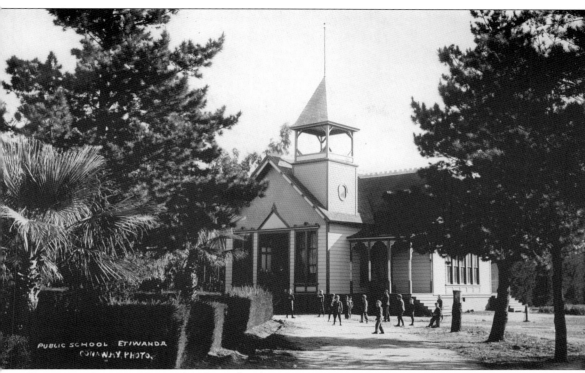

ETIWANDA SCHOOL. Etiwanda's first school in 1883 was a one-room schoolhouse at Etiwanda Avenue and Baseline Road. The above school was built in 1890 to accommodate two teachers. Both the Perdew and Grapeland school districts had closed their schools and joined the Etiwanda district. (Model Colony Room.)

W. H. FROST JOHN FROST

FROST BROTHERS

RETAIL DEALERS IN

GENERAL MERCHANDISE
HAY AND GRAIN

ETIWANDA, CAL.

Lower California Distributor of the AUTOCAR: M. S. BULKLEY & CO., 1801 So. Main Street, Los Angeles, Cal.

FROST STORE BUSINESS CARD AND STORE INTERIOR. The Frost brothers, Jim and W.H. Frost, opened their store in Etiwanda Colony in 1910. Like each colony or community in the area, there was a store, post office, barbershop, and other necessities located together to serve the people. Small general stores like this carried household and farming items, as well as groceries. The motorized bicycle (below) was used to deliver mail and groceries.

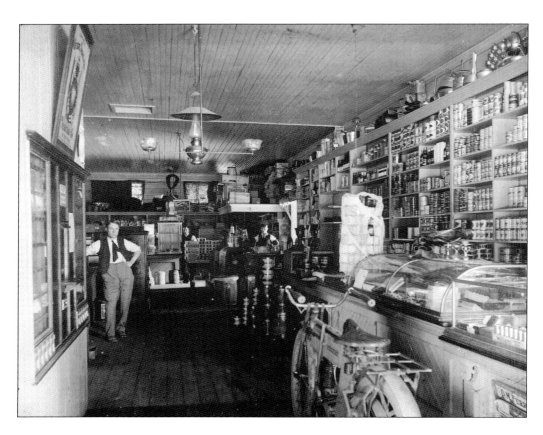

REEL DANCING. The Polka Palace provided Etiwanda's nightlife. Often, an accordion player and a band provided the music for dancing. In a reel dance, the first couple makes an arch with their arms, then the next couple comes through and does the same. The last couple must dance through the long tunnel everyone made. Music and dance styles change, but the love of celebrating with friends does not. (Millie Glenny.)

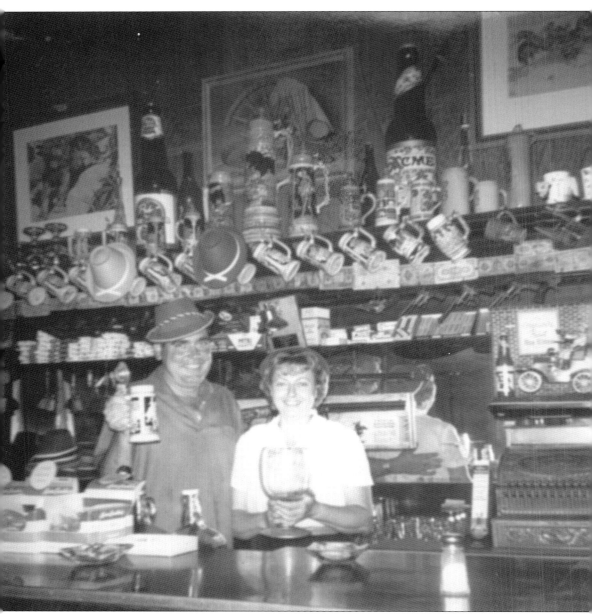

THE POLKA PALACE. Tillio and Anne Casaletti opened a roadside fruit and beverage stand in 1927. People enjoyed having a place to gather to eat and drink. Soon, there were evening dances on an outdoor dance floor. As business increased, the building was added onto. The Casaletti Polka Palace remained in business over the years and was renamed the Etiwanda Roadhouse when ownership passed from the Casaletti family. (Millie Glenny.)

Five

THE LAND OF WINERIES

VINEYARDS AND WINERIES. During Cucamonga Valley's vintage years, there were more than 99 vineyards and wineries in the area. The weather and soil produced richly flavored grapes that created excellent wines, making Cucamonga Valley the center of California winemaking.

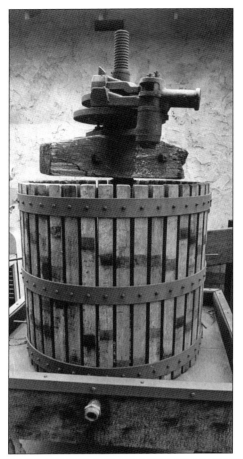

THOMAS WINERY. In the days of the Cucamonga Rancho, Tiburcio Tapia used small winepresses, such as this one at the Thomas Winery. The bucket was filled with ripe grapes. Then, the screw-type handle was turned until all the juice was pressed out of the grapes. The juice was transferred to oak barrels where, over time, the grape juice fermented into alcohol and became wine. Thomas Winery has the distinction of being California's oldest winery, having been established in 1839 by Tiburcio Tapia. In the 1860s, John Rains planted 125,000 vines. In 1920, the Thomas family purchased the winery and sold it to the Filippi family in 1967. In the mid-1980s, the Filippi family sold the winery. The building and silo became restaurant and shop property. A wine-tasting room there carries on the vintner tradition.

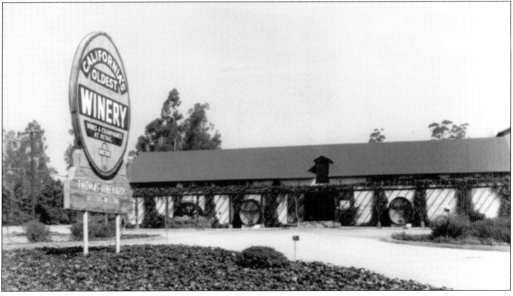

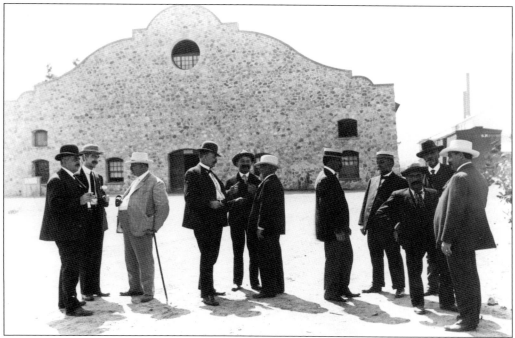

GUASTI WINERY. Secundo Guasti founded the Italian Vineyard Company (IVC) in 1883. IVC was the world's largest vineyard, with over 5,000 continuous acres of vines. Guasti brought whole families from his native Italy and provided them with housing, a school, firehouse, and a church. Its beautiful stone buildings were later owned by Garrett and Company, the Biane family, and the Filippis. The vast property was sold to developers in 2006, who preserved a portion of the historic Guasti village. Above, vintner owners gather at Guasti to talk business in the early 1900s. Below, the ranch boss supervises workers in the vineyard. Guasti built a small railroad through his property to haul harvested grapes to the winery buildings.

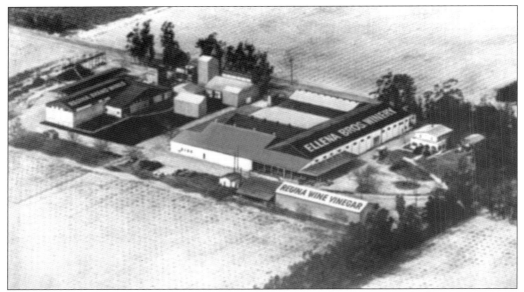

REGINA WINERY, 1960. The Ellena brothers named their winery Regina, which means "queen" in Italian, for theirs was "Queen of Wines." The winery seen above is located in Etiwanda on Foothill Boulevard. At present, it is owned by the Filippi family and serves as a winery and tasting room.

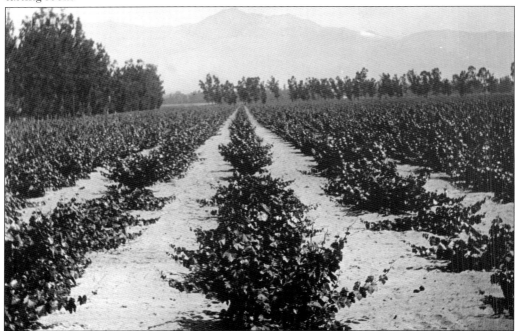

VIRGINIA DARE VINEYARD. The north-south alignment of the vine rows allowed for maximum sunlight coverage on all the vines' leaves from dawn to dusk, thus, creating a bigger and better crop. These vines have long since been covered over by a movie theater and bowling alley at the corner of Haven Avenue and Foothill Boulevard. Despite the building boom, there are still a few pockets of vineyard land dotting the city.

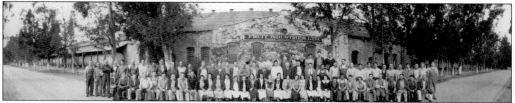

CUCAMONGA VINEYARD COMPANY. This winery on Eighth Street has had a variety of names throughout its history. It was first established in 1870 as the Padre Winery. The winery was then rebuilt in 1909 by the Vai family. It later became the Cucamonga Vineyard Company. It was once the nation's largest producer of vintage and nonvintage sparkling wines. During Prohibition, its name was changed to Fruit Industries, Ltd. It is now the Pierre Biane Winery owned by the Biane family.

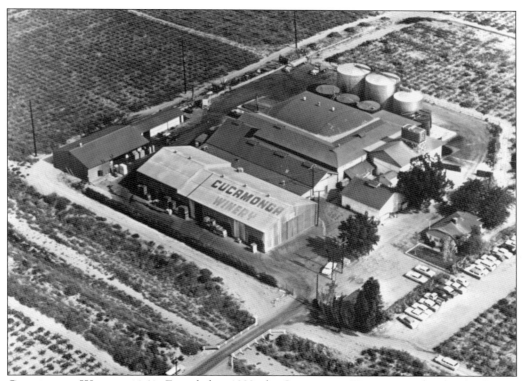

CUCAMONGA WINERY, 1962. Founded in 1933, the Cucamonga Winery is said to be the first in the wine district to use Cucamonga in its name. Alfred Accomazzo, an Italian who immigrated to California in 1902, helped to found the winery. His son Arthur managed the winery until its closing in 1975. At one time, it had approximately 800 acres of vineyards spread across the town.

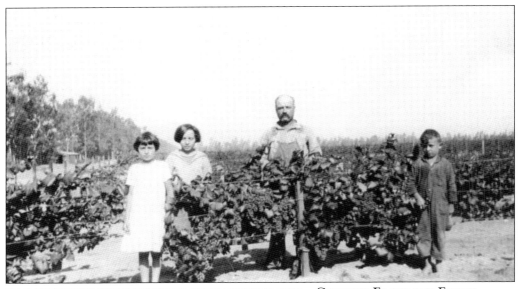

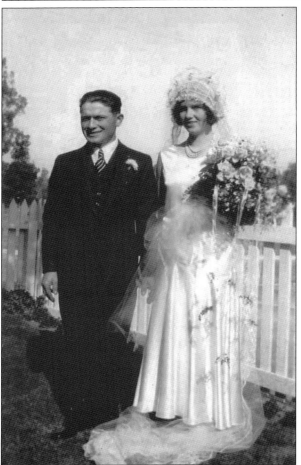

GIOVANNI FILIPPI AND FAMILY. Giovanni Filippi and three of his grandchildren stand among his vines. Filippi and his son Joseph arrived in the United States in 1918 from Northern Italy to join relatives already working at the Guasti winery. After working a few years for Guasti, Filippi set out his own vines in 1922. As fate would have it, Prohibition began about the same time. The family survived the ban on alcohol by selling sacramental wine to the churches and shipping grapes out of the area. At left is Giovanni's son, Joseph Sr., on his wedding day. He and his bride, Mary, would be married for 68 years. Joseph carried on the family's wine business his father began. He passed away in 1998.

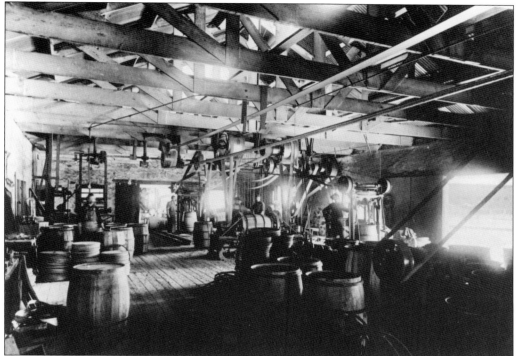

WINERY COOPERAGE. The cooper shop is where the oak wine barrels are made. The above photograph shows the cooperage that was part of the Regina Winery. The photograph below shows Guasti's coopers in the early 1900s. The Italian men with their broad mustaches sit upon the barrels they have made.

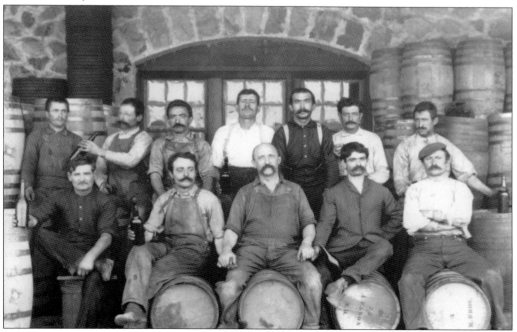

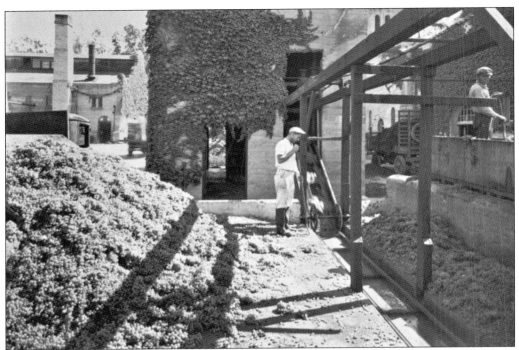

VIRGINIA DARE, C. 1930S AND 1940S. A worker has to use a shovel to transfer grapes onto a conveyor belt that takes them into the crushing room. Trucks brought loads of fresh, ripe grapes straight from the fields. The original crushing room still exists on the property, although it is not available to enter.

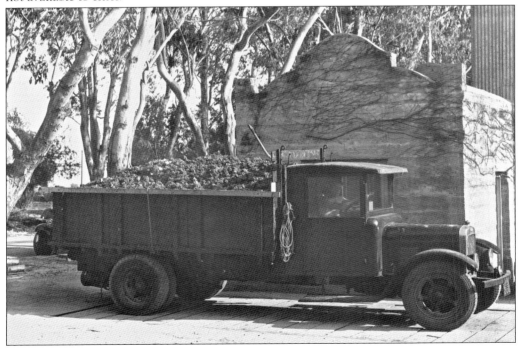

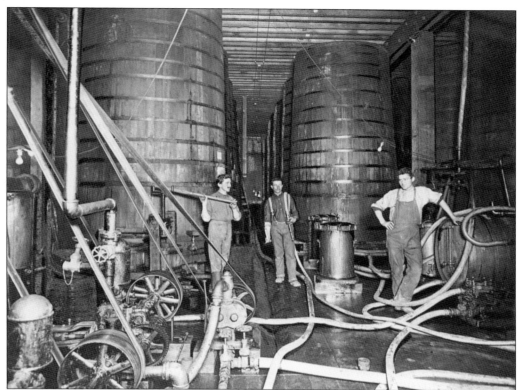

WINE VATS. Once the grapes are crushed and pressed, they are transferred to different vats for processing and fermentation. What looks like sludge floating on top of the vats below is called musk. The musk is made up of the seeds, skins, and pulp of the grapes. Wine gets its color from the skins during fermentation. Workers must carefully pump the wine to circulate the musk for the flavor to evenly develop.

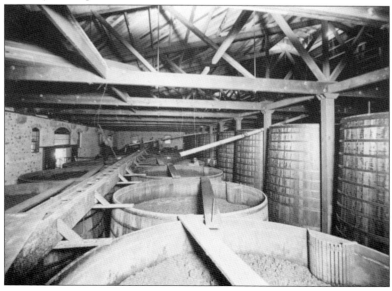

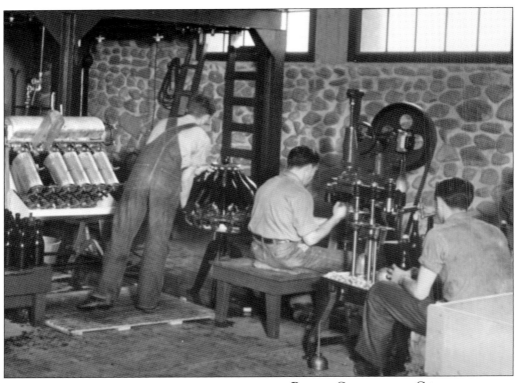

BOTTLE CORKING AND CHAI ROOM. Above, workers are using a hand-operated corking machine that was a modern device for its time. Corks must be tightly inserted into the bottles to prevent air from entering and turning the wine bad. At left is the Chai room. A worker supervises the blending and mixing of wines to achieve the right flavor. Each kind of wine requires a specific type of grape and winemaking process.

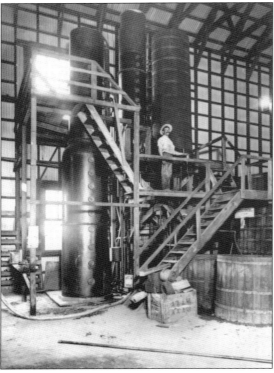

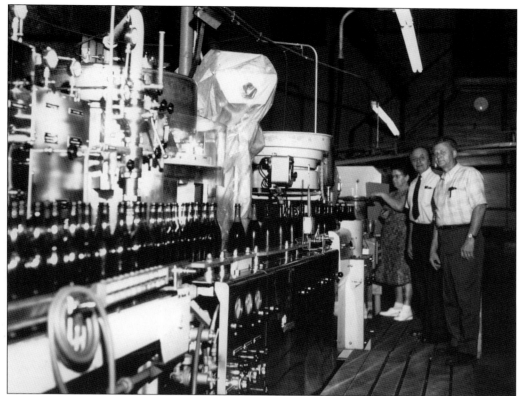

MODERN WINEMAKING. The scientific term for a winemaker is an oenologist. Above, the bottling crew checks the automatic bottler machine. It is a much faster process than the technique on the opposing page. Sterile bottles can be quickly filled and sealed tighter than a person could by operating the hand press. Automatic processes help ensure each bottle has the same flavor as the others. Below, an oenologist at the Biane Brookside winery studies the chemical makeup and sugar content of wines produced there. New techniques enable vintners to change the wines to appeal to customers' evolving tastes.

PROHIBITION. In 1919, Congress approved an amendment that prohibited the manufacture and sale of alcohol under the theory that it would prevent crime and violence in the home. Churches were to keep a certain amount of sacramental wine. Families were allowed to have a small amount of household wine. The Roaring Twenties was a period marked by bootlegging. Whether or not the group above celebrated with a hidden flask is not known, but rum-running did go on in some of the wineries in Cucamonga. East Coast bootleggers prized the sweet wine alcohol base to make their illegal "hooch" and regularly came to Cucamonga to purchase alcohol. Below is a photograph commemorating the end of Prohibition in 1933. The Cucamonga Valley Wine Company celebrated by sending Pres. Franklin Roosevelt the first case of California wine in December 1933.

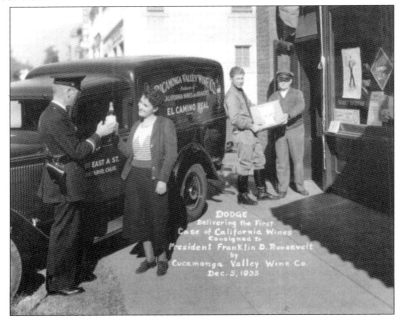

REGINA WINE AND WINE VINEGAR. Because of Prohibition and rising taxes, wineries had to get creative in running their business. Wine vinegar was the answer for Regina Winery. By using the pure Cucamonga water and a small amount of wine, their well-known wine vinegar was created. Regina formed an alliance with supermarkets, such as Stater Brothers Markets, to sell their wine and wine vinegar in stores. This increased business and lessened the need to draw individual customers out to the winery. (Both, Claude Ellena.)

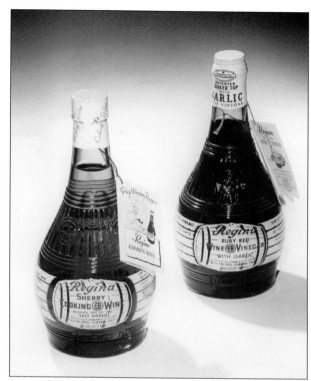

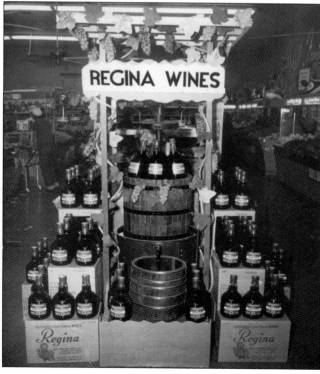

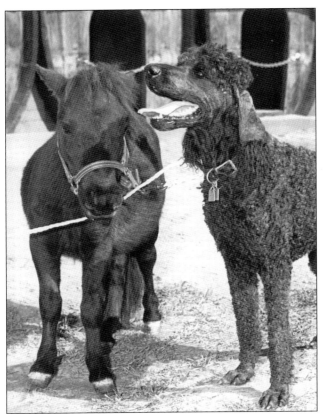

FALABELLA HORSES AT REGINA WINERY. In order to draw more families and visitors, wineries added restaurants, tasting rooms, and events to lure customers. One attraction the Regina Winery added was the miniature horse called the Falabella, which they imported from Argentina. Regina called them "Lilliputian Horses." They were as small as a dog and used wine barrels as their stables. Families were invited to stay for lunch and bring the kids for a ride on a tiny stagecoach pulled by the miniature horses. (Both, Claude Ellena.)

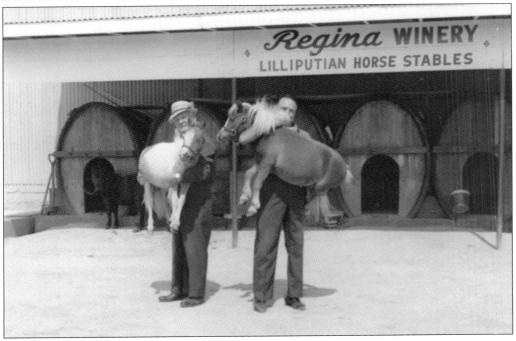

JACK BENNY AND LUCILLE BALL. Above, Jack Benny, who made the name Cucamonga famous in his radio show and, later, his television show, came to Regina Winery in January 1966. The wineries were celebrating the new bill that allowed them to have restaurants on the premises. Regina family members say there was always someone famous dropping by the winery. Many Hollywood people passed through Cucamonga on their way to their ranches in Chino, cabins at Lake Arrowhead, and homes in Palm Springs. Lucille Ball and Desi Arnaz routinely would stop by to pick up a case of brandy or wine from the Regina Winery on their way to Chino. (Above, Claude Ellena; right, public domain.)

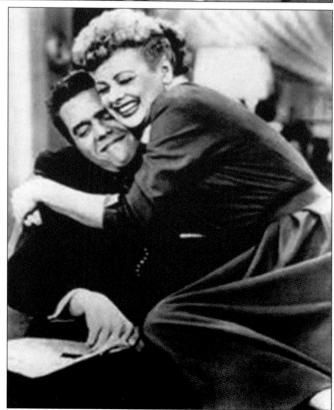

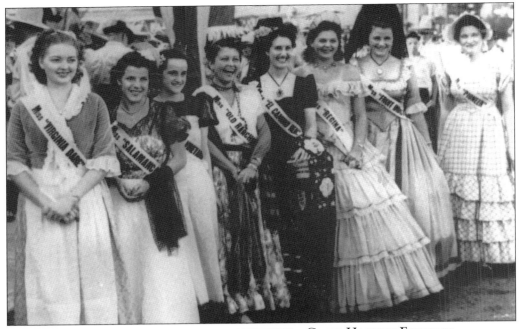

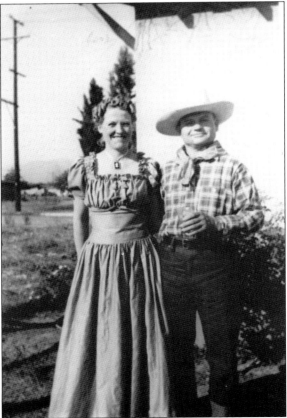

GRAPE HARVEST FESTIVALS.
Sometimes called Fiesta Days, the grape harvest, a time of celebrating in the wine community, was usually held in September. Costumes, games, and activities were all part of the celebration. Above, a beauty pageant between wineries required each lady to dress up and depict the name of the wine, such as an Italian queen for Regina, a pioneer girl for Pioneer winery, and so on. Left, at another Fiesta Days celebration are John Ellena and his wife, Arless, in western outfits near their home in Etiwanda. In addition to fun and games, a priest would come to the church in Guasti for the blessing of the grapes. (Left, Claude Ellena.)

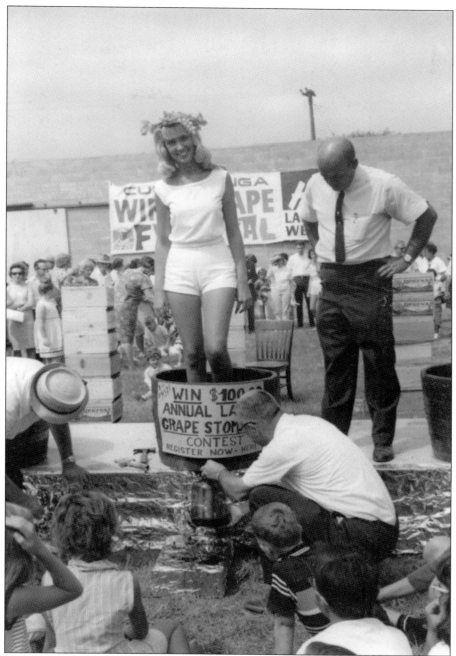

GRAPE QUEEN STOMPING CONTEST, c. 1975. Styles changed since the early Fiesta Days. Young ladies competed to be Grape Harvest Queen by stomping grapes in a barrel. The lady who squished the most juice from the grapes with her bare feet was the winner. The Grape Festival designed contests to bring more prospective customers to the wineries. The need to drive out to wineries to buy spirits had been eliminated by grocery stores offering it on their shelves. As the agricultural economy changed and wineries closed, the festival became smaller, but the tradition continued. (Claude Ellena.)

UNUSUAL GIFT SHOP. A gift shop inside a huge wine vat was an attempt to lure visitors into the Thomas Winery from Route 66 during the 1960s and early 1970s. Wineries tried a variety of promotional gimmicks to bring in customers.

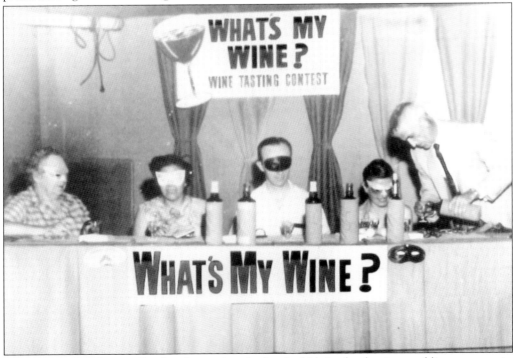

GRAPE FESTIVAL GAMES. Food and game booths for the kids in the daytime and live concerts in the evenings still draw visitors. The game pictured is a spoof of popular television show *What's My Line?*. Blindfolded contestants sampled wines for a chance to win a prize.

Six

CHAFFEY COLLEGE

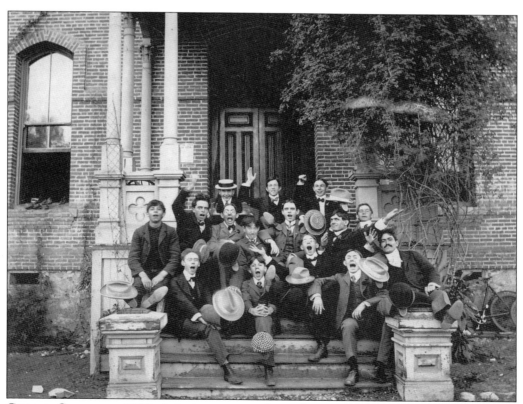

CHAFFEY COLLEGE, C. 1900. A singing group made up of young men hams it up for the camera on the steps of Chaffey High School and the College of Agriculture on Euclid Avenue in Ontario. (Chaffey College.)

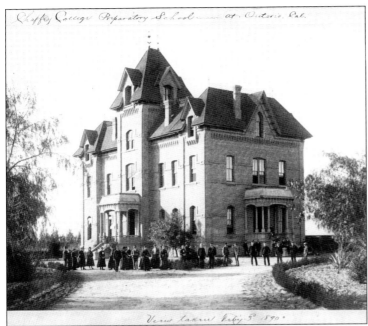

Chaffey College Preparatory School — at Ontario, Cal.

View taken Feby 3° 1890.

THE FIRST CHAFFEY HIGH SCHOOL AND COLLEGE. Chaffey College of Agriculture opened in 1885 as a private boarding school at the corner of Fourth Street and Euclid Avenue in Ontario. It was a combination high school and junior college. Students came from as far as Hemet and Riverside, where there were no public schools yet, to attend. The first year, there were 15 students and three teachers. (Chaffey College.)

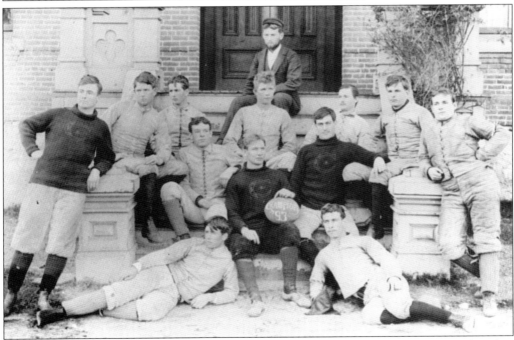

CHAFFEY BEATS USC, 1893. The victorious Chaffey champion football team poses for what would become a historical moment—USC being beaten by a junior college. There were only a handful of colleges in Southern California at that time. George Chaffey arranged for the trustees of the University of Southern California to oversee the funding of Chaffey College. But in 1901, when USC tried to merge Chaffey College, George Chaffey cut ties with USC and formed a new board. (Chaffey College.)

WILLIAM CHAFFEY. Younger brother William Chaffey, wearing his mayoral robes, was a soil expert and horticulturalist. Both Chaffey brothers were eager to have a school of agriculture to serve to the youth of the colonies' farms. William Chaffey's influence continued on the experimental farm at Chaffey College. He remained in Australia after the brothers founded two cities there. (Model Colony Room.)

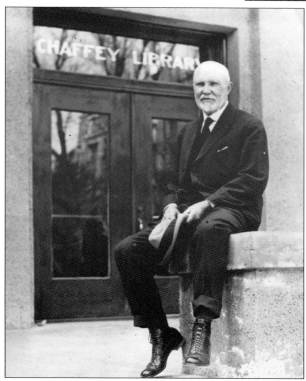

OUTSIDE THE FIRST CHAFFEY LIBRARY. Older brother George Chaffey was the inventive, ambitious engineer who designed Euclid Avenue and laid out the colonies of Etiwanda and Ontario. His curiosity of how things could be made resulted in him becoming an inventor at an early age. Both Chaffeys had a thirst for knowledge and a desire to try new things and succeed at business. The Chaffeys also thought a school of higher learning would attract quality settlers with families to the colonies. (Chaffey College.)

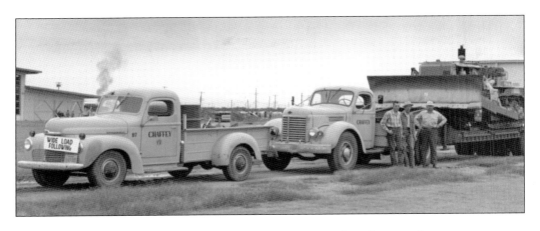

CHAFFEY COLLEGE CONSTRUCTION, 1959. Above, trucks brought in large earthmoving equipment to level the hillsides for building the new Alta Loma junior college campus. The plentiful rocks and boulders had to be cleared away before foundations for the classrooms and buildings could be laid. Below, carpenters build cabinets by the dozens for the new campus's classroom and offices. Work took only about a year before the school was ready to open. Chaffey College continued building more facilities throughout the years. At present, it has satellite college locations in Fontana, Chino, and Ontario. The Ontario campus continued as headquarters for the Chaffey High School District. (Both, Chaffey College.)

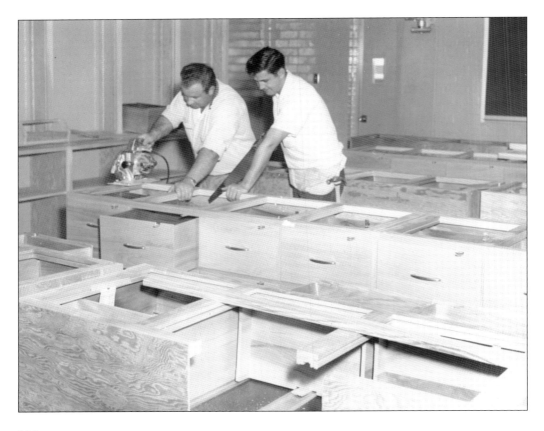

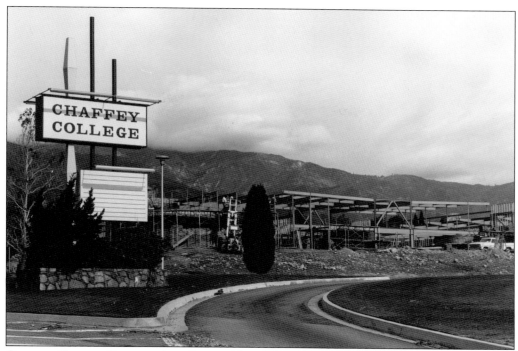

CHAFFEY COLLEGE OPENS IN ALTA LOMA. Above, the original 1960 marquee reflects the modern space-age design of the time at the college's entrance on Haven Avenue. The buildings were mostly built low and long in the style of that time. All the college's departments moved to the Alta Loma campus from the original Ontario site. Below, students in the 1970s enjoy the majestic view of the mountains and wide sloping green spaces of the campus. To the south, students have a view of the valley below them. Not shown are the plentiful rabbits that once plagued the area's first settlers. Rabbits bounce along under the bushes as students walk to class. In the evening, the wide lawns are nibbled upon by dozens of hungry bunnies enjoying the tender green grass. (Both, Chaffey College.)

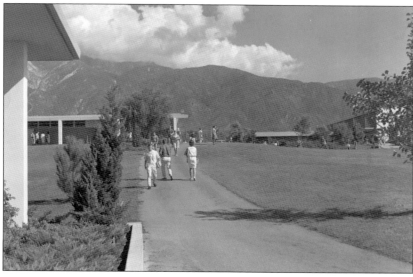

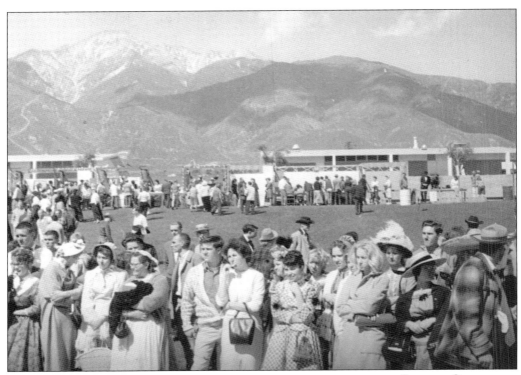

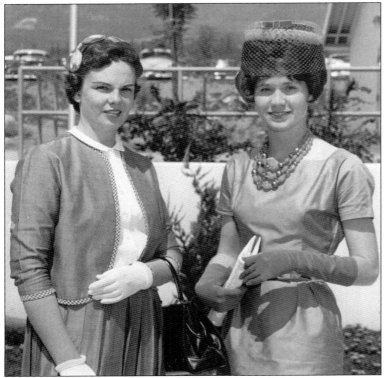

CHAFFEY COLLEGE, 1960. Above, a festive crowd of students gathered to watch presentations at the new college. Many of the students were attired in costumes from various time periods of the college's past. Left, the opening of a brand-new campus is an important event. A pair of young ladies are properly dressed for such a college affair in 1960s style, complete with hats and gloves. Today, they would be considered to be wearing period costumes. (Both, Chaffey College.)

Seven

SAM MALOOF, MASTER WOODWORKER

SAM MALOOF. Sam Maloof of Alta Loma was a world renowned furniture craftsman whose simple artistic furniture is found in the Smithsonian Museum. Born in 1916 in Chino, California, he was the seventh child of Lebanese immigrants. He stands in front of his beloved avocado tree at his original Alta Loma home. The tree could not be moved to the new location when the State Route 210 was extended through Rancho Cucamonga. (Maloof Foundation.)

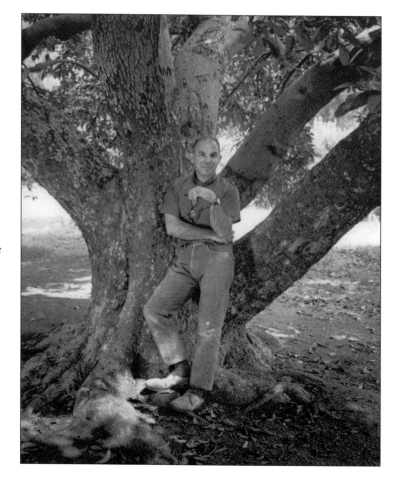

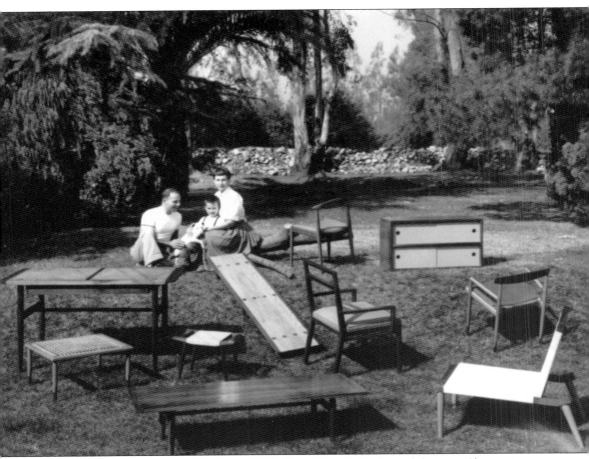

MALOOF FAMILY WITH FURNITURE, C. 1950. Sam, his wife, Freda, and their son Slimen sit among samples of his work. He is recognized as an influential pioneer of contemporary décor. *People* magazine dubbed him "the Hemingway of Hardwood. His business card simply said, "Woodworker." As newlyweds, Sam and Freda had no money for furniture. Sam used discarded wood and borrowed tools to build his own. Soon, friends were asking him to build pieces for them, and his world-famous, custom furniture business was born. (Maloof Foundation.)

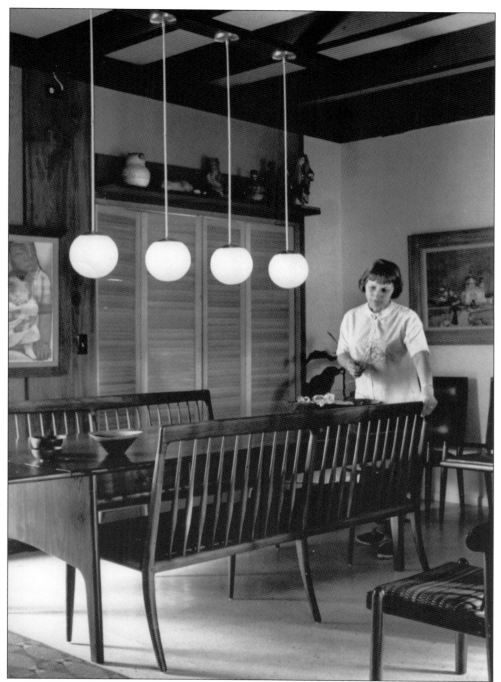

FREDA MALOOF AND TABLE. A customer purchased a Maloof dining table with drawers. Some time after receiving it, she complained to Maloof about an awful smell coming from the table. Maloof went to investigate. He opened all the drawers one by one. The drawer at the place where the owner's little boy sat was the culprit. Evidently, her little boy had been secretly hiding his vegetables in the drawer during dinnertime. (Maloof Foundation.)

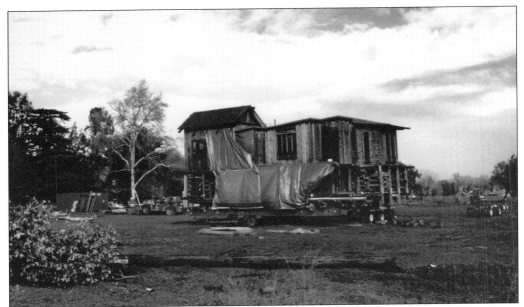

MALOOF HOUSE MOVING. The Maloofs moved to Alta Loma in 1953, where Sam built a studio to continue making furniture. He transformed what he called a "dingbat bungalow" to a 22-room timbered home with a hand-carved spiral staircase. In 1999, the house was moved three miles to make room for the extension of State Route 210. (Sioux Bally-Maloof, Heart Stone Arts.)

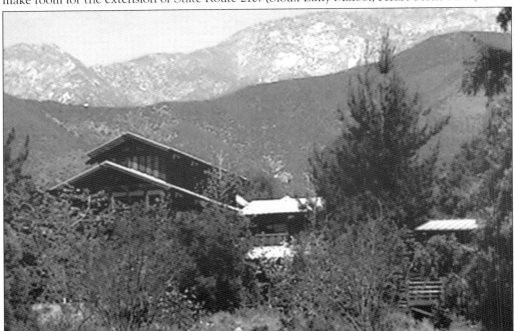

SAM MALOOF HOUSE. Various possibilities were reviewed before deciding where the Maloof home and workshop needed to be relocated. The house was successfully moved to the northern end of Carnelian Avenue. The house is listed on the National Registry of Historic Places. The house and gardens on the six-acre property are open to the public for tours. (Dawn Collins.)

SAM MALOOF AT WORK. Maloof was self-taught and would cut parts freehand on a band saw. He considered every angle and grain design on every piece when he was creating his furniture. Maloof furniture is patiently hand shaped and sanded until it is silky smooth. There are no sharp edges on his furniture. Pieces are then assembled without nails or metal hardware. (Maloof Foundation.)

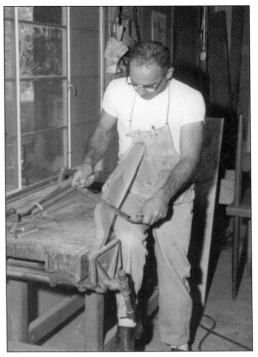

MALOOF AND PRESIDENT REAGAN. The signature Maloof piece, his exquisite rocking chair, was the first piece of furniture to become part of the White House Art Collection. Maloof and his wife, Freda, met Pres. Ronald Reagan during the presentation of the chair. Former president Jimmy Carter also owns a Maloof rocker. A woodworker himself, Carter gave Maloof a signed photograph that said, "To my woodworking hero." (Maloof Foundation.)

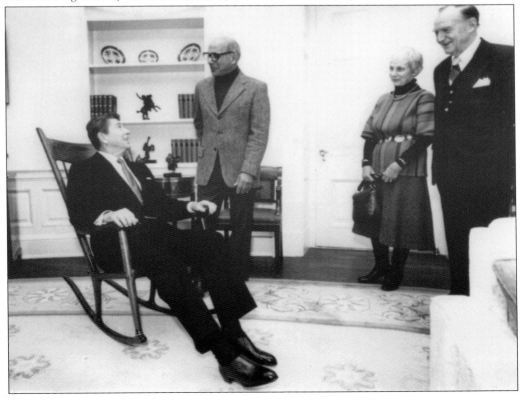

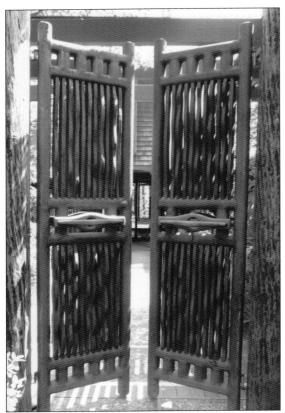

HAND-CARVED GATE. The Maloof workshop, still on the premises, continues to build furniture to order since Maloof's death in 2009. Maloof was never secretive about his techniques. He trained fellow craftsmen to carry on his furniture business. Maloof created a book and video that gives step-by-step instructions on how to make furniture like his classic rocking chair. His beautiful artwork, such as this gate, is found throughout the grounds and buildings. (Dawn Collins.)

MALOOF'S HONORS. Maloof was awarded numerous honors over the years. Pictured are Maloof and his wife, Freda, with an honor from Claremont College's School of Theology. In 1985, Maloof was awarded the MacArthur Genius Fellowship. In 2003, the California Historical Society awarded him their Californian Award for Creativity. The California State Legislature proclaimed Maloof a "Living Treasure of California." (Maloof Foundation.)

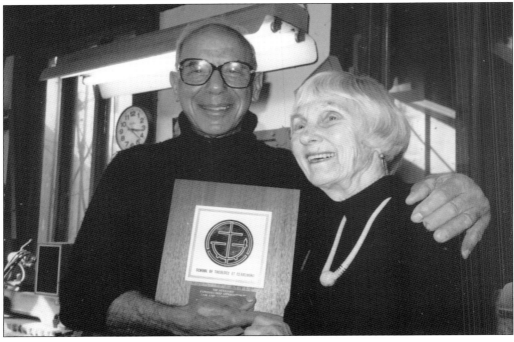

Eight

Flood, Freeze, and Fire

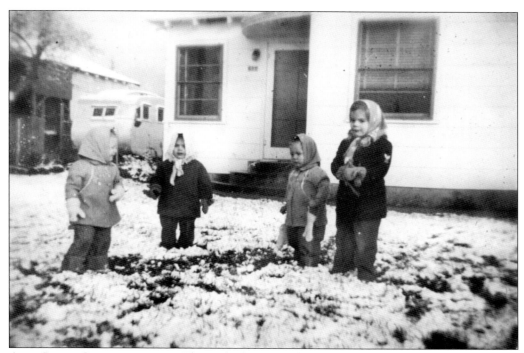

Alta Loma Children, 1969. The end of 1968 and the beginning of 1969 were marked by unusually cold and wet weather. These delighted children play in the snow that covered their yards during the night. Children were used to having summer swim parties, and these little Californians appeared not quite sure what to do with all the white snow. (Esther Billings.)

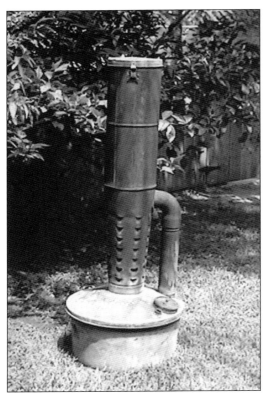

SMUDGE POTS AND ORCHARD HEATERS. Snow may have delighted children, but it spelled trouble to the farmer. Citrus trees do best in warm, sunny climates. Freezing temperatures can damage fruit and even kill the tree. This grove heater is better known as a smudge pot. A smudge pot was placed between two trees and filled with oil, which growers lit. The black, sooty smoke from the burning oil would linger around the trees. The rising warm air from the smudges prevented the icy air from damaging the fruit. Men would work all night to keep the smudges lit. The newer orchard heaters (advertised below) burned cleaner than the homemade bucket smudges that were eventually banned. (Left, author's collection; below, Cooper Museum.)

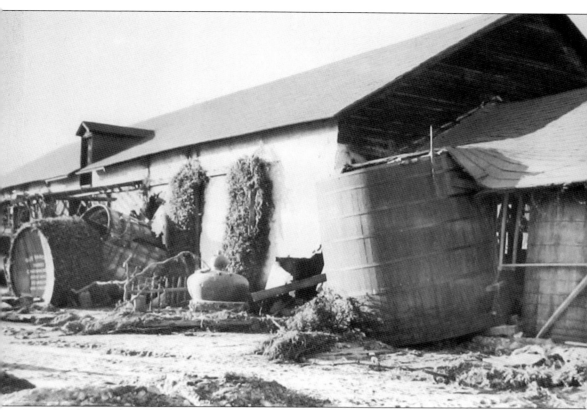

TIPPING WINERY VATS. Disaster struck the morning of January 22, 1969, when the earthen reservoirs in the canyons broke, releasing floodwaters that quickly covered the western side of town. Eleven people were killed. At the Thomas winery, the waters rushed in the back door and out the front. The force tipped and knocked over the huge vats. A second, smaller flood occurred a month later in February. To add insult to injury, the Filippi family had completed renovations on the historic building just months before. Much of that renovation work had to be redone. (Ed Dietl.)

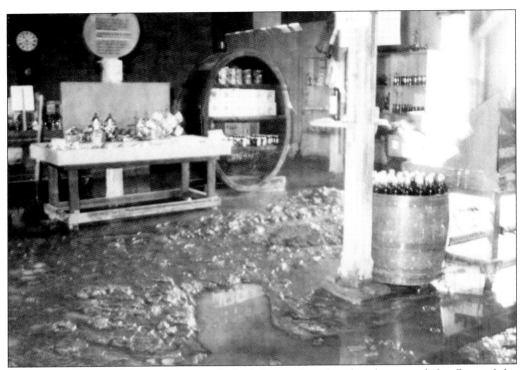

FLOOD DAMAGE INSIDE THE WINERY. A thick layer of mud and rock covered the floor of the winery. Fortunately, the enormous boulders that were thrown about by the flood did not knock it down, though they did considerable damage elsewhere. Below, mud is cleared from a second flood a few weeks later.

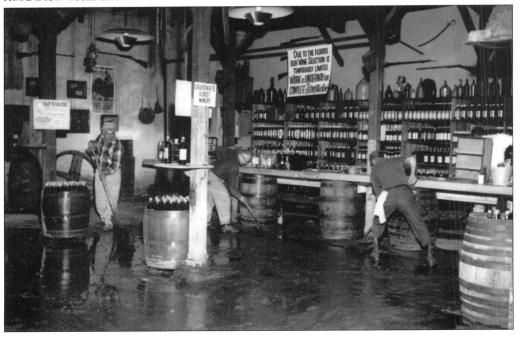

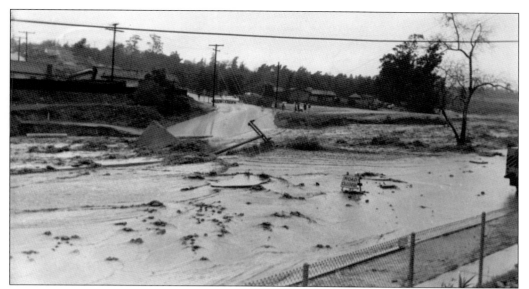

FLOODED RED HILL COUNTRY CLUB DRIVE. The floodwaters knocked down power lines and flooded streets. Residents were stranded in their homes for days until the waters receded. Flooding continued downhill into Ontario. The photograph is taken standing on Carnelian Avenue looking west towards Red Hill Country Club Drive. Today, a bridge crosses a deep, cement flood control channel there.

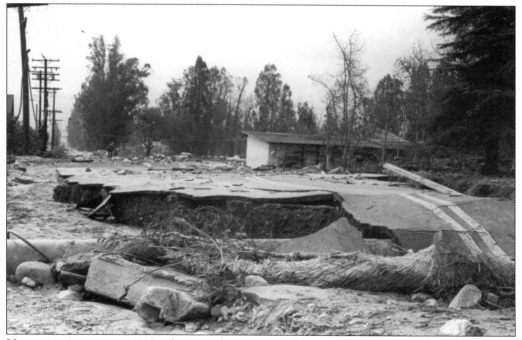

VINEYARD AVENUE, 1969. Looking south on Vineyard Avenue, the wake of havoc the flood left is evident. Buckled roads and power outages destroyed homes and businesses and were reasons Gov. Ronald Reagan surveyed the scene by helicopter and proclaimed a state of emergency for Cucamonga.

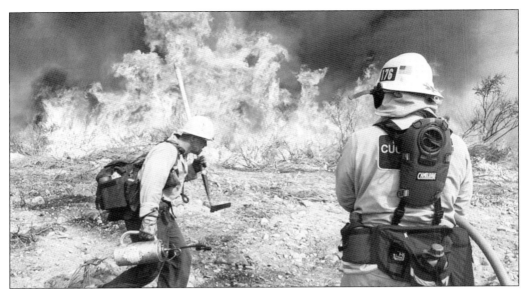

GRAND PRIX FIRE, OCTOBER 2003. The massive Grand Prix brush fire began October 21, 2003, in the hills north of Fontana. The Old Waterman Fire then joined the Grand Prix Fire. When the blaze crossed the Los Angeles County line, it was called the Padua Fire. It was one of more than a dozen wildfires burning in Southern California. President Bush announced California in a state of emergency. (*San Bernardino Sun.*)

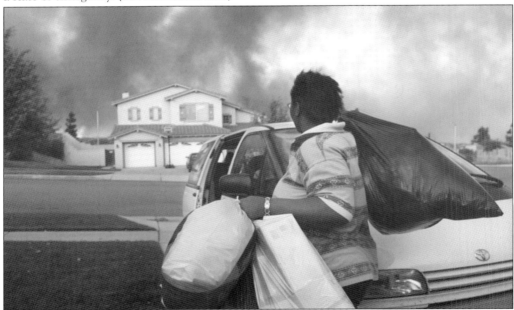

EVACUATION OF HOMES. Along the northern edge of Rancho Cucamonga, neighborhoods were evacuated. Eleven homes were destroyed but no deaths reported. The air across town was smoky. The sky was brown with an eerie orange glow as the fire burned across Cucamonga Peak. The US Forest Service (USFS) report surmised the true cost of the over 100,000-acre fire was well over one billion dollars, the most costly natural disaster in California's history at that time. (*San Bernardino Sun.*)

Nine

BECOMING RANCHO CUCAMONGA

THE SEAL OF RANCHO CUCAMONGA. The city's seal features something old (the Virginia Dare Winery) and something new (Epicenter Stadium), along with mountains, palm trees, citrus fruit, and a large cluster of grapes. (Dawn Collins.)

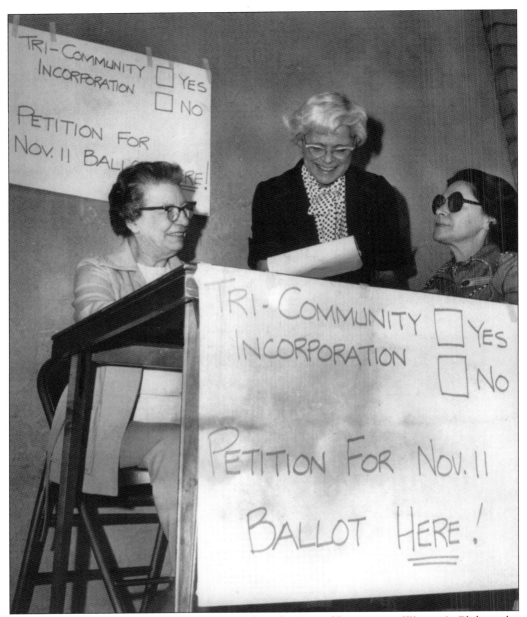

COUNTING BALLOTS, NOVEMBER 8, 1977. The Alta Loma/Cucamonga Woman's Club at the Lion's Club on Baseline Road count ballots in the election to determine if the three towns of Alta Loma, Cucamonga, and Etiwanda will incorporate to become one city. There were strong feelings on both sides. Ballots were tabulated on a chalkboard by the volunteers. The Lion's Center, built by volunteers, temporarily served as the mayor's first office. (Woman's Club of Rancho Cucamonga.)

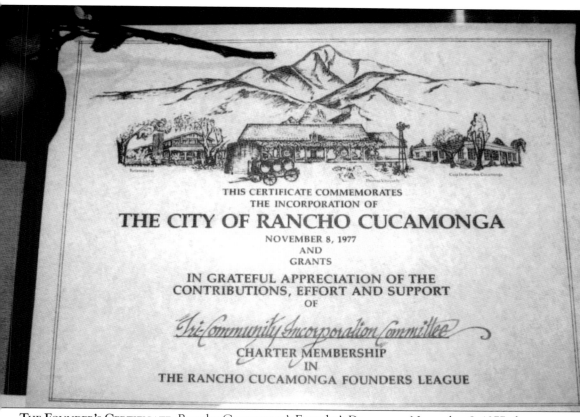

THIS CERTIFICATE COMMEMORATES
THE INCORPORATION OF

THE CITY OF RANCHO CUCAMONGA

NOVEMBER 8, 1977
AND
GRANTS

IN GRATEFUL APPRECIATION OF THE
CONTRIBUTIONS, EFFORT AND SUPPORT
OF

Tri-Community Incorporation Committee

CHARTER MEMBERSHIP
IN
THE RANCHO CUCAMONGA FOUNDERS LEAGUE

THE FOUNDER'S CERTIFICATE. Rancho Cucamonga's Founder's Day was on November 8, 1977, the day Alta Loma, Cucamonga, and Etiwanda communities voted to incorporate the three cities into the city of Rancho Cucamonga. The city was officially incorporated on November 30, 1977. The city's new name was up for suggestions in the summer 1976. Suggestions varied from funny to serious and included Altacucawanda, Etimonga, Cualtawanda, Tres Pueblos, Chaffey Hills, and Red Hill City. The name recognition Jack Benny gave the area and the original land grant name won out. "All aboard for Rancho Cuc-a-monga!"

FIRST MAYOR AND CITY COUNCIL. Pictured above is Rancho Cucamonga's first city council. The top five candidates from the field of 36 became the city council. For this first election, it was decided the candidate with the most votes out of the field of 36 would be mayor. That person was James C. Frost. The next four highest vote earners made up the city council seats. Pictured from left to right are (first row) Mayor Jim Frost and Charles A. West; (second row) Phil Schlosser, John Mikels, and Michael Palombo. In the photograph below are Major Frost (left) and the president of the Builders Industry Association. They are reviewing the new signage near Haven Avenue. Thousands of homes and businesses have been built since 1977.

EPICENTER STADIUM, 1991. The Epicenter Stadium was built and intentionally named to be the center of community events and recreation. It became the first large gathering place of the newly incorporated city. Concerts, shows, and city sports leagues take place on its grounds, as well as baseball with the Rancho Cucamonga Quakes. Following with the tongue-in-cheek earthquake theme, the team mascots are dinosaurs Tremor and his little buddy Aftershock, who rose from the center of the earth when the Rancho Cucamonga Quakes shook the ground. (Epicenter Stadium.)

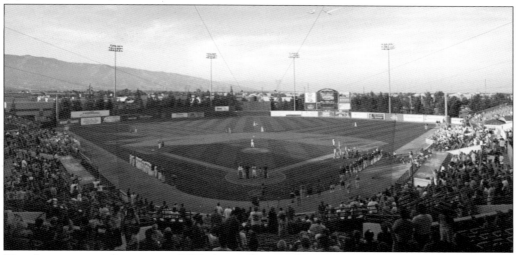

VIEW INSIDE OF THE STADIUM, C. 1991. An unobstructed summer evening's view of the mountains is shown in this early photograph from inside the Epicenter Stadium. The California single-A team has represented Major League Baseball teams, such as the Dodgers, the Los Angeles Angels of Anaheim, the San Diego Padres, and the Florida Marlins. (Epicenter Stadium.)

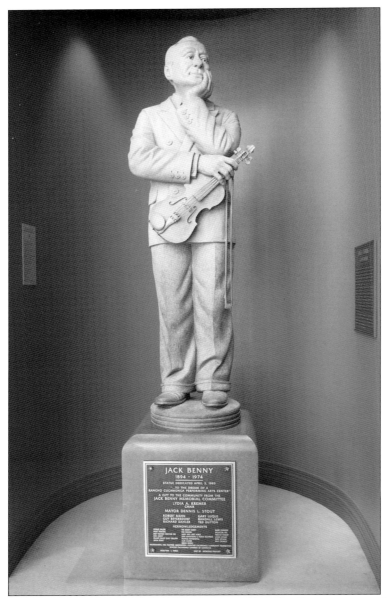

JACK BENNY STATUE. This statue was donated to the city of Rancho Cucamonga, and it originally stood in the entrance of Epicenter Stadium. The Benny statue has since found a more fitting home in the foyer of the Lewis Family Playhouse. Benny's 1945 train station featured Mel Blanc as the loudspeaker announcer of the train leaving for "Anaheim, Azusa, and Cuc-a-monga!" Blanc's voice is more familiarly known of that of Bugs Bunny, Elmer Fudd, and other Looney Tunes characters. Benny continued using Cucamonga in his skits when his show moved to television. Benny, who lived in the Hollywood area, would have personally been familiar with Cucamonga as the winery town out in the boondocks and on the way to Palm Springs. It is fun to remember such things. It should be noted that the hardworking immigrants and early Americans who came to Cucamonga to plant those vines and build those businesses are the ones who really deserve the credit for putting the city on the map. (Dawn Collins.)

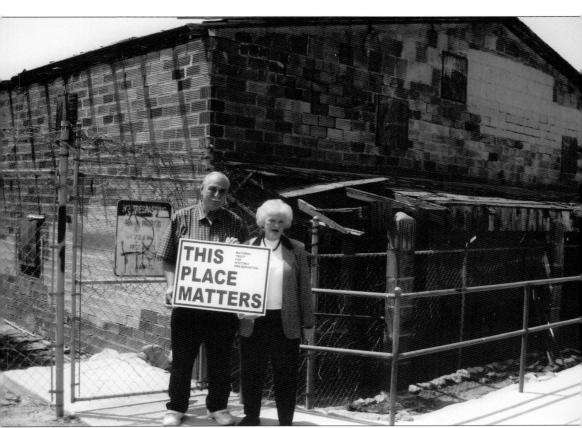

ED AND SANDY DIETL AT CHINATOWN. Ed and Sandy Dietl do their part in campaigning for the preservation of the China Town House on behalf of the Historical Preservation Association of Rancho Cucamonga, one of several local history organizations. Community pride runs deep in Rancho Cucamonga's cities within the cities. Historical treasures continue to be discovered. There are great needs for additional support and interest. (Ed Dietl.)

The following organizations and websites are great sources of historical information: Historical Preservation Association of Rancho Cucamonga, HPAofRC.org; Etiwanda Historical Society, Etiwandahistoricalsociety.com; Historical Preservation Program of the City of Rancho Cucamonga, www.rclocalhistory.com; Chaffey Community Cultural Center—The Cooper Museum, Coopermuseum.org; and California Historic Route 66 Association, Route66ca.org.

www.arcadiapublishing.com

MAP SEARCH

Discover books about the town where you grew up, the cities where your friends and families live, the town where your parents met, or even that retirement spot you've been dreaming about. Our Web site provides history lovers with exclusive deals, advanced notification about new titles, e-mail alerts of author events, and much more.

MADE IN THE USA

Arcadia Publishing, the leading local history publisher in the United States, is committed to making history accessible and meaningful through publishing books that celebrate and preserve the heritage of America's people and places. Consistent with our mission to preserve history on a local level, this book was printed in South Carolina on American-made paper and manufactured entirely in the United States.

This book carries the accredited Forest Stewardship Council (FSC) label and is printed on 100 percent FSC-certified paper. Products carrying the FSC label are independently certified to assure consumers that they come from forests that are managed to meet the social, economic, and ecological needs of present and future generations.

FSC
Mixed Sources
Product group from well-managed forests and other controlled sources

Cert no. SW-COC-001530
www.fsc.org
© 1996 Forest Stewardship Council

Find Your Place in History.